ALL F🐾R ANIMALS

"Pick up this book full of simple, practical tips that will launch you on the path to a cruelty-free lifestyle. It's cool to be compassionate, and this book provides all the nuts and bolts."
—Berkeley Breathed, cartoonist and children's book author

"Whether you're an activist or just want to know more, this book will further your understanding of animal rights issues and what you can do to help."
—Anita Roddick, founder and co-chair, The Body Shop

"There isn't a person on this planet who couldn't be a better steward of the incredible gift that animals bring our lives. **All for Animals** shows some blazed trails to a higher level of commitment, compassion, and caring for animals."
—Marty Becker, DVM, co-author
Chicken Soup for the Cat & Dog Lover's Soul

"Moving and unforgettable, **All for Animals** acts as a catalyst which challenges all who read it to embrace an attitude of proactive kindness."
—Mark Beckloff, founder, Three Dog Bakery

ALL F🐾R ANIMALS

Tips and Inspiration for
Living a More Compassionate Life

Karen Lee Stevens

To Meghan,
May the fur be with you!
Karen Lee Stevens
September 19, 2003

2001 · FITHIAN PRESS, SANTA BARBARA, CALIFORNIA

Second Printing

Copyright © 2001 by Karen Lee Stevens
All rights reserved
Printed in the United States of America

Published by Fithian Press
A division of Daniel and Daniel, Publishers, Inc.
Post Office Box 1525
Santa Barbara, CA 93102
www.danielpublishing.com

LIBRARY OF CONGRESS CATALOGING-IN-PUBLICATION DATA
Stevens, Karen Lee, (date)
 All for animals : tips and inspiration for living a more compassionate life /
by Karen Lee Stevens
 p. cm.
 Includes bibliographical references (p.).
 ISBN 1-56474-364-0 (pbk. : alk. paper)
 1. Animal rights. 2. Animal welfare. 3. Animal rights movement.
 I. Title
 HV4711'.S84 2001
 179'.3—dc21 00-010401

In memory of Cassidy
1984–2000

"A thousand angels dance around you."

—Savage Garden, "I Knew I Loved You"

Acknowledgments

First I would like to thank my dad, the late Henry "Steve" Stevens, and my mom, Rhoda Stevens, without whose support this book would not have been possible.

I would also like to extend heartfelt thanks to all my manuscript readers. I am very grateful for your excellent comments and suggestions and for your words of encouragement along the way: Gene Bauston of Farm Sanctuary; Barbara Berggreen; Andy Cuk; Alison Greene of the People for the Ethical Treatment of Animals; Daniel Kossow of The Humane Society of the United States; Marcia Kramer of the National Anti-Vivisection Society; Simon Oswitch of Animal Emancipation, Inc.; Manuel Rodriguez; Julia Salo of the Doris Day Animal League; Don Shook; Susan Solomon; Stefanie Spray Jandl; Ruth Stevenson; and Karen Bridgers and Julie Ann Mock for their cruelty-free tips.

My thanks and appreciation also go out to all the writers who sent in stories. This book would not have been complete without your wonderful words of hope, courage, and dedication to animals.

I am especially thankful to my editor, Linda Anderson, for her wisdom and for sharing my enthusiasm for animals and vision for the book; to John Robbins for his wonderful foreword; to Cork Millner for his expert guidance; and to my publisher, John Daniel, and his staff, for their support and guidance through the book publishing process.

Contents

A PRAYER FOR ANIMALS

by Albert Schweitzer (1875–1965)
philosopher, physician, and humanitarian

Hear our humble prayer, Oh God,
for our friends the animals,
especially for animals who are suffering,
for any that are hunted or lost
or deserted or frightened or hungry;
for all that must be put to death.

We entreat for them all
thy mercy and pity,
and for those who deal with them,
we ask a heart of compassion
and gentle hands and kindly words.
Make us, ourselves,
to be true friends to animals
and so to share the blessings of the merciful.

Foreword

Our little cat, Princess, died a few days ago. She had been with us for sixteen years, giving us all love and affection and delight in her unique ways. I loved her dearly and will miss her terribly. At the same time, I know that she lives on. I, for example, am a far richer person for having known her so deeply. Thanks to her incredibly dear presence, my heart has been raised to a greater power.

Have you ever known an animal, a non-human one, I mean, who has enriched you as a human being? Have you ever had a relationship with a non-human animal who has given you more of yourself, made you more fully human, given you access to understanding and feelings that you would not otherwise have known?

Most of us have, and in fact I would be sad for anyone who hasn't had the extraordinary experience of having his or her heart touched by a being of a different species. There is something truly magical about how they can enter our worlds and, just by being themselves, leave us forever changed.

How do we return the favor? Most of us treat the animals we call pets well. We lavish our affection on them and receive much in return. But there is so much more for us to learn, so many ways in which we can, fairly easily really, come to care more wisely and more efficaciously for our fellow creatures.

That's where this marvelous book comes in. *All for Animals*, by Karen Lee Stevens, is chock full of helpful hints, exciting ideas, super suggestions, and all manner of positive possibilities for living with enhanced respect and joy with our animal friends. You don't have to be an animal rights activist to benefit from this book, nor do you have to be someone with oodles of time to spare. The genius of this book is that it takes you right where you are, and

points the way to actions and resources that allow caring for animals to be what it should be: easy, simple, and hugely rewarding.

I am sure my little cat Princess would have been delighted that Karen has written this book. And I am equally sure that countless other cats, dogs, birds, rabbits, pigs, cows, snakes, and just about every other kind of animal, too, are likewise glad. If you calm your mind and open your heart and listen, I'll bet you can hear them now, rejoicing, thankful that you have picked up this book, and grateful that you are the kind of person who cares about the well-being of creatures like them.

We're going to have quite the party some day. I can barely imagine the joy that humanity will know when we finally start to treat other creatures with the respect that we would like to receive, if we were in their paws or hoofs and they were dominant upon the earth. With *All for Animals*, Karen Lee Stevens takes us a good deal closer to that day.

John Robbins
author of *Diet for a New America*
founder, EarthSave

Introduction

It was a rundown warehouse, the kind of building in which you could envision housing old cars or greasy machinery at one point in its history. I spied a cat sitting on the cold, hard steps at the entrance to what once was the front doors of the structure. As I approached the cat and sat down on the step, he trotted over and promptly jumped into my lap and started purring.

I didn't know it at the time but I had just met my destiny.

I could see two old pet food and water dishes off in the corner, long crusted over from disuse. This cat had to be starving and thirsty. I washed the bowl with water from an old faucet as well as I could and filled it with fresh water. I have never seen a cat drink so long and with such enjoyment. With that done and feeling pretty good about myself for helping this poor critter, I said goodbye and promised to be back to see him again soon.

The next day was Saturday and a rainstorm hit the city with force. As I snuggled contentedly under the covers, my mind went to the kitty I had met the day before. What if he were out in all this rain? What if he were shivering, lonely, and scared? I had to do something. I got up and immediately drove to the warehouse where I had seen the kitty the day before and, sure enough, there he was, huddled under the eaves of the old building. I strode over, scooped him up, and without a backward glance placed him on my lap in the car and drove home. He made no effort at protesting; it was as if he knew I had only the best of intentions.

I didn't really notice it when he was outside, but as I took a closer look at him at home, I saw that he had the most beautiful, big blue eyes I had ever seen on a cat. With the color of highly-polished sapphires and the depths of the deepest ocean, this cat drew me in with his gaze, and we made a deep connection.

As the months and years passed, "Cassidy" and I continued to share a special relationship. He was there as I began mulling over the idea of starting an organization to help animals. He was there as I began researching animal rights and animal testing issues. Every time I learned about another atrocity by a human against an animal, I would sit with Cassidy and gaze into those soulful blue eyes and ask, "Why? Why, in this highly advanced society, is animal abuse happening?" Cassidy's unwavering gaze and quiet, dignified demeanor helped me to continue my research, to dig deeper, to find answers, and ultimately to educate others.

Just as I completed this book, Cassidy, while nestled on his favorite blanket, passed away peacefully in my arms. He was sixteen years old. I firmly believe he was brought to me to help fulfill my purpose of sharing the message of compassion toward all animals. I hope he realizes how important he has been in my journey to help other animals in need.

After all, it was *our* destiny.

The Special Animals in Your Life

Do you have a special animal companion in your life? When you look into his eyes, what do you see? Do you consider this animal an integral part of your life, a member of the family? Most of us give our companion animals a great deal of affection and would never allow them to be hurt, abandoned, or abused. In return, they give us unconditional love and devotion.

This book allows you to explore many ways in which you can show even more love and appreciation for your own companion animals and gives you the opportunity for learning how to peacefully co-exist with *all* the animals who share our earth.

All for Animals doesn't describe painful animal experiments or show graphic pictures of animal suffering. Instead, it offers quick and easy ways you can be kinder to animals and treat them with more respect. Whether you choose to do a few or all of the things suggested in this book, you'll feel good about yourself for helping the animals.

Animals everywhere thank you for your compassion!

ALL FOR ANIMALS

I.
An Introduction
to Living a
Compassionate Life

1. Who Cares about Animals?

"Love of animals is a universal impulse, a common ground on which all of us may meet. By loving and understanding animals, perhaps we humans shall come to understand each other."

—Louis J. Camuti, D.V.M. (1898-1981)
author of All My Patients Are Under the Bed

A Home for the Homeless:
Peace Plantation Today
by Anna C. Briggs

In my years of working with animals, I've gotten to know some wonderful people. I've depended on these individuals to help get our enormous job done, just as others depend on us to help them care for their animals when they are no longer able.

Often we receive calls from elderly or ill people who find themselves unable to keep their beloved pets any longer. They are heartbroken at the idea that they must give up their faithful companions.

I'll never forget one of these individuals—an elderly man called John. I heard about John through a lady who was a friend of mine. She had seen him in the check-out line of a grocery store in Washington, and noticed that he was buying nothing but cat food.

"You must have a lot of cats," she remarked to him.

"No, only two," he told her. "I can't afford any more."

My friend offered to help John by giving him some money. She was worried because he wasn't buying any food for himself, and she knew that often impoverished pet guardians will go hungry rather than deprive their animals of food.

But John refused her offer, confiding that his immediate worry was not cash but finding a place to live.

"I'm living in a rooming-house, and the landlady tells me I have to leave my quarters by the first of the month. I can't find a new place where I can take my cats and I just don't know what to do," he said.

My friend called me, arranging for me to come and get John's cats. He called these precious companions Itty and Bitty. The thought of parting from them was breaking his heart. When I met him, he started to cry.

"If I could only have gotten some work, maybe I could have found a home for them," he said. John was at least eighty years old at the time, and none too well, but I thought perhaps there was a chance he could find some gainful employment.

"Well, what do you do?" I asked him.

"I'm an auto mechanic. But I'd do anything. Even if I could find work as a gardener! Do you know anybody who needs a gardener?"

I wanted to laugh. I myself barely knew the difference between a rose and a dandelion, and Peace Plantation was in dire need of somebody to keep the grounds in order. "I do!" I said. I offered John the job in exchange for room and board for him and his cats.

He was thrilled. John and Itty and Bitty came to our place in April. By June, the gardens and lawns were beautiful. I thought I had a gold mine in John! Sadly, he died the following October. But he never had to be separated from his beloved animal friends, and at the very end of his life he knew the satisfaction of being useful, of being wanted, and of being cared for, even if it was only for a very short time.

John was like many of the animals we take in at Peace Plantation—not in the best of health, no longer in the prime of life, overlooked by an uncaring world. For me, his story is a good example of my philosophy that all life is precious, that every living being deserves an opportunity to live out his or her days in peace. And that's why I am so happy to have a thriving Peace Plantation

operating in Walton, New York and a healthy National Humane Education Society, working hard to protect animals all across our great nation.

Anna C. Briggs is cofounder of the National Humane Education Society (NHES). Founded in 1948, the NHES is a non-profit organization located in Leesburg, Virginia which fosters the sentiment of kindness to animals in children and adults.

A Brief History of Animal Rights

In the 1600s, the French philosopher, mathematician, and scientist René Descartes made the statement, "I think, therefore I am." He believed animals lacked the ability to think and were impervious to pain. This belief was shared by the majority of people at the time. Then, Jeremy Bentham, a well-known philosopher of the late eighteenth and early nineteenth centuries, acknowledged the inherent sentience of animals with these questions: *"Can they reason? Nor, can they talk? But, can they suffer?"* From then on, we began to look at animals in a different way.

In 1975, Peter Singer, another well-known philosopher, wrote a book entitled *Animal Liberation,* which takes an in-depth examination of animal experimentation and animal rights philosophies. With this book, hailed by many animal rights groups as their "Bible," the animal rights movement was born.

The animal rights movement is made up of hundreds of thousands of intelligent, compassionate people from around the world. The animal rights philosophy maintains that animals are sentient, feeling beings and have the right to be free from:

- Human exploitation such as being used for human entertainment (zoos, circuses, rodeos),
- Pain and experimentation (vivisection),
- Human consumption (factory farms and slaughterhouses).

The animal rights movement does not put the intrinsic value of humans against the intrinsic value of animals; instead, it asks that we consider the rights of both humans and animals. It encourages

us to regard all life as sacred, from the snail, to the dolphin, to the human being. It asks us to take responsibility, not only for our own lives, but for the way we treat fellow beings who share our earth. Through the food we eat, the clothing we wear, and the activities we choose, we, as consumers, have the power to be a voice for the animals.

The Importance of Animals in Our Lives

As we begin the twenty-first century, we are seeing more clearly than ever before that animals are an integral part of our own lives. Animals are not inferior to us; they are merely different from us. They share many of the same emotions, such as joy, fear, sorrow, and compassion.

In the book *For the Life of Your Dog* by Greg Louganis, Olympic gold-medal diving champion, and Betsy Sikora Siino, Greg shares the story of how his dog comforted Greg's father during an illness: "Dogs know when someone in the family is hurting. I often think of when I was taking care of my dad during the last weeks of his life during his struggle with cancer. One day, I took him for a walk in his wheelchair with my Great Dane, Freeway. Freeway stayed with my dad, not at my side as he usually would. He stayed at my dad's side. When we stopped, he sat down and put his head over my father's arm which is the dog equivalent of putting a hand on your shoulder. He knew my dad needed him. My dad reached out and petted him and said, 'I wish I was more mobile so I could have a dog.' I said, 'Dad, we're here. He's *our* dog.' Freeway knew we were all family. He knew he was comforting my father."

2. What You Can Do to Help Animals

"This we know: The earth does not belong to man; man belongs to the earth. All things are connected like the blood that unites us all. Man did not weave the web of life, he is merely a strand in it. Whatever he does to the web, he does to himself."

—*Chief Seattle, 1854*

People often ask me, "Why do you care so much about animals? You know, you can't save them all, so what's the point?" I may not be able to change the world by helping animals, but by helping even one animal, I can change *their* world.

I am often reminded of the story about a single starfish, which I'll share with you. This story was originally written by Loren Eiseley.

A Single Starfish

One day, an old man was walking along the beach. It was low tide, and the sand was littered with thousands of stranded starfish that the water had carried in and then left behind. The man began walking very carefully so as not to step on any of the beautiful creatures. Since the animals still seemed to be alive, he considered picking some of them up and putting them back in the water, where they could resume their lives.

The man knew the starfish would die if left on the beach's dry sand, but he reasoned that he could not possibly help them all, so he chose to do nothing and continued walking.

Soon afterward, the man came upon a small child on the beach who was frantically throwing one starfish after another back

into the sea. The old man stopped and asked the child, "What are you doing?"

"I'm saving the starfish," the child replied.

"Why waste your time? There are so many, you can't save them all, so what does it matter?" argued the man.

Without hesitation, the child picked up another starfish and tossed him back into the water.

"It matters to this one," the child explained.

Making the Transition to a Cruelty-free Lifestyle

The decision to be cruelty-free is a lifestyle choice you make not to harm animals in your daily life; choosing to purchase cruelty-free household products, personal care products and cosmetics (those that have not been tested on animals and do not contain animal ingredients), choosing not to eat meat, fish, poultry, eggs, or dairy products, and choosing not to wear clothing made from leather, fur, wool, or silk. Being cruelty-free also means abstaining from visiting zoos, rodeos, circuses, and any other place or event where animals are used for human entertainment. You may be either a vegetarian (someone who does not consume meat, poultry, or fish) or a vegan. A vegan replaces all dietary sources of animal products with only non-animal products.

Becoming "cruelty-free" can be as simple as switching brands of car anti-freeze or throwing bird seed instead of rice at weddings. Anti-freeze tastes sweet to animals, but is highly toxic to them. Try non-toxic Sierra anti-freeze. And rice swells in a bird's stomach, often proving fatal.

There is often some confusion when the term "cruelty-free" is used in relation to household products and cosmetics. Does the term "cruelty-free" mean the *finished* product is not tested on animals? Does it mean a product's *ingredients* are not animal tested? Are there animal ingredients in the product (such as lanolin)? A consumer products company may claim its ingredients and finished products are not tested on animals, but they don't have an agreement with their outside suppliers who may test ingredients on animals.

How to Recognize Cruelty-free Products

But how can you be confident you're choosing truly cruelty-free products? In 1996, a new, very stringent standard was set forth by the Coalition for Consumer Information on Cosmetics (CCIC) to help consumers make ethical purchases. The new standard is called "The Corporate Standard of Compassion for Animals." CCIC is comprised of The Humane Society of the United States, the Doris Day Animal League, People for the Ethical Treatment of Animals, the American Anti-Vivisection Society, New England Anti-Vivisection Society, American Humane Association, and Beauty Without Cruelty, USA. It has joined with the executives from The Body Shop, John Paul Mitchell Systems, Tom's of Maine, and over 150 other cosmetics and household products manufacturers to promote the new guidelines for product testing.

According to Holly Hazard, Executive Director of the Doris Day Animal League, "The new Corporate Standard of Compassion for Animals program is being proposed for all cosmetic and household products manufacturers. It will result in important changes for consumers trying to find out if any animal testing occurs, prior to marketing, for the products they buy and use."

Dr. Martin Stephens, Vice President for Animal Research Issues at The Humane Society of the United States, points out that, in the past, the term "cruelty-free" generally referred to companies that did not perform or commission animal testing of their *finished* products. "The new standard is much tougher. It says that manufacturers may not purchase any *ingredients* from suppliers that conducted or commissioned animal testing on them."

Companies that comply must require written assurances from all of their suppliers and intermediary agents that, with respect to the specific ingredients, formulations and products supplied, no animal testing has been conducted on their behalf.

Cosmetics and household products include many products regulated under Federal law as either cosmetics or drugs or simultaneously as both. The standard also applies to the kinds of products we traditionally find in the "household products" aisles of supermarkets such as cleaning supplies, bleaches, laundry and dish

detergents, cleaners, floor polish, floor wax, ink, correction fluid, glue, and even toys.

A new, internationally recognized logo began appearing in the marketplace in the Spring of 1999 in the United States, Europe, and Canada. The first of its kind, the logo will be displayed through advertising, packaging, and point-of-sale purchases on cosmetics and household products, guaranteeing to consumers that no animal tests were used in the development and production of that product. The logo program is supported by a unique coalition of more than fifty animal advocacy organizations worldwide.

For more information on the Corporate Standard of Compassion for Animals, contact:

Julia Salo
The Coalition for Consumer Information on Cosmetics (CCIC)
P.O. Box 75307
Washington, DC 20013
(888) 546-CCIC
www.leapingbunny.org

As consumers, we have the opportunity to make a real difference in the lives of innocent animals simply by changing our shopping habits a bit. While your own companion animal is happy and safe at home, millions of other animals suffer needlessly in outdated, unnecessary product tests. You can help bring an end to animal testing by making a personal commitment to read labels before you buy a product and look for the new rabbit logo or the statement "This product not animal tested" on the labels of your favorite personal care and household products.

3. Alternatives to Testing on Animals

"To my mind the life of the lamb is no less precious than that of a human being. I should be unwilling to take the life of the lamb for the sake of the human body. I hold that, the more helpless a creature, the more entitled it is to protection by man from the cruelty of man."

—*Mohandas K. Gandhi (1869–1948)*
The Story of My Experiments

Animal Bill of Rights

As an animal, I have:

The right to be treated with respect.

The right to physical, psychological, and emotional health.

The right to not be exploited.

The right to live in a suitable habitat.

The right to be valued for who I am, not for how I can be used.

The right to cooperatively share the Earth with other species.

The right to live as much as possible according to my nature and to express my individual character.

Progress Toward More Humane Testing Methods

Scientific animal studies fall into three general categories: product testing, biomedical research, and classroom education. This chapter focuses on product testing.

A great deal of progress has been made and many large and small consumer product companies now use alternatives to live

animal tests. These tests have proven to be more reliable, less expensive and, of course, more humane.

It is important to note that there is NO law requiring companies to test their personal care and household products on animals before marketing them to consumers. Why then don't all consumer product companies become cruelty-free? The two main reasons are the fear for human safety and the fear of product liability suits.

In 1959, *The Principles of Humane Experimental Technique* was published in London defining the concept of animal testing alternatives as the "Three R's": refinement, reduction, and replacement. Alternatives to live animal tests are procedures that follow the "Three R's": *Refine* existing test methods. *Reduce* animal usage. *Replace* animals.

The International Foundation for Ethical Research (IFER), which has provided grant money to scientists conducting research without using animals, adds an important fourth "R" to this set of beliefs: *Responsibility*—to both human and nonhuman animals.

Revlon Cosmetics was one of the first large companies to fund research for alternatives with a $750,000 contribution to the Rockefeller University in 1979. The Johns Hopkins Center for the Alternatives to Animal Testing (CAAT); the International Foundation for Ethical Research; the Cosmetic, Toiletry, and Fragrance Association; and the Soap and Detergent Association followed suit and started their own programs to validate alternatives. Keep in mind that, while companies search for alternatives, animal use may actually *increase* because the old test (using animals) must be done alongside the new test (without animals) to validate the results.

Animal testing is not a viable way to verify the safety of a particular product or ingredient. There is too much difference between animal and human physiology. For instance, rabbits are most commonly used in product tests because, unlike humans, their eyes do not contain tear ducts to wash away a foreign substance.

Animal testing is still very much in existence at large corporations such as Lever Brothers, Johnson & Johnson, Procter and

Gamble, and Warner-Lambert. Many of these same companies, however, are making an effort at reducing their animal use. For instance, Procter and Gamble made an announcement in 1999 that they were able to reduce animal testing by 80 percent on finished formulations of their non-food and non-drug products.

There are now over 550 cruelty-free consumer product companies. A current list of cruelty-free companies can be found in the Resources chapter at the end of this book.

Alternatives to Animal Testing

What type of alternatives are in use today? The most common type of alternative methods are: in-vitro tests, computer software, databases of tests already done (to avoid duplication), and human "clinical trial" tests. Use of animal cells, organs, or tissue cultures is also deemed an alternative although, obviously, animal lives are sacrificed for the use of their body parts.

In vitro (meaning, literally, "in glass") as opposed to *in vivo* (meaning "alive") has flourished because of advances in tissue culture techniques and other analytical methods.

According to John Frazier and Alan Goldberg, of The Johns Hopkins Center for the Alternatives to Animal Testing, the main disadvantages of animal tests are "animal discomfort and death, species-extrapolation problems, and excessive time and expense." Animal protection advocates stress that the main disadvantage is the inhumane treatment of animals in many tests due, in part, to the fact that anesthesia for the alleviation of pain is often not administered during or after the procedure. Many researchers allege that using anesthesia will interfere with test results.

Progress toward the widespread use of alternatives to animal testing will continue to gain strength as public awareness and support of alternatives increases. As consumers, we can make a difference for animals by purchasing only products deemed "cruelty-free" and writing or calling the companies that still do animal testing and letting them know why you will not purchase their products. To learn more about alternatives to animal testing, visit the Altweb Web site at: www.jhsph.edu/~altweb.

4. Laboratory Animals

"It is totally unconscionable to subject defenseless animals to mutilation and death, just so a company can be the first to market a new shade of nail polish or a new, improved laundry detergent.... It's cruel; it's brutal; it's inhumane; and most people don't want it."

—*Abigail "Dear Abby" Van Buren*
(testifying before the House Judiciary Committee in support of the Consumer Products Safe Testing Act, March 1988)

From Lab Dog to Love Bug
by Stephanie Morris Girton

How does a family with normal dogs cope with the introduction of a rescued laboratory animal straight from the gravel-bottomed runs of a university's research center?

Due to a loss of funding, a beagle colony was released from experimental use at a University of California-Davis facility. My husband, Larry, and I have two beagles of our own, both registered therapy dogs who visit the elderly and handicapped. We felt our family was complete with our female Roxie and our canine senior citizen Big Al. And to tell the truth, I was repulsed when I first glimpsed our potential adoptee. He was gaunt, bow-legged, with ear tattoos, elongated snout, and mascara-like rimmed eyes. He looked more like a cross between a fox and a basset hound than a beagle.

Up-close human contact was new to him, and he simultaneously managed to cower and run away. "It's okay," cautioned the volunteer. "You have to remember that these guys aren't used to people and they're pretty shy."

I was soon billing and cooing at this poor creature. As I signed the adoption papers, I enthused, "Do you know our beagles are registered therapy dogs? I'd sure like to turn him into one!"

The woman responded, "I've never heard of any lab animals trusting strangers. You'll have your hands full just getting him to come to you. He might bond with your other beagles and ignore you altogether."

"Great," I muttered.

What Are Doggie Treats?

Larry and I named him Mr. Jo-Jo. Almost immediately, we realized his life of isolation from human contact, except for feeding and waste removal, didn't prepare him for integration into our household. Mr. Jo-Jo was timorous, unskilled at being friendly, and skittish. He didn't know what doggie treats were or how to chase backyard critters. Walking on grass and having a world to explore not bound by gravel and wire were new, heady experiences for him.

While Larry and I worked, our three "kids" had the run of our yard. Gradually becoming approachable Mr. Jo-Jo not only responded to his name but started to increase the contact he allowed us. Our first joining was the touch of his spindly legs. "Sweetheart, his paws are on my thighs," I told my husband. "I just wish he'd let me pick him up and pet him." Pretty soon, he ventured onto our laps, our chests, and with forepaws gently braced, searched our faces for duplicity.

What did we do that was special?

Nothing, really.

We are extremely lucky that this exceptional animal needed very little training and formal socialization. Discipline has rarely been needed. Housebreaking was no problem. He seemed to learn from Roxie. Within a couple of months, Mr. Jo-Jo was sleeping with Roxie in a wicker basket in our living room.

Gone were the days when Mr. Jo-Jo wouldn't let anyone, including my husband and me, approach him. Snug and secure in his new home, he was an animal who, when spying us watching

him from the house, would wag his entire body in welcome from forty feet away! Under his institutionalized exterior was an animal who wanted to get close. He was comfortable with a human chin he could tuck his head under, and also sought one out.

He Passes His Tests

Mr. Jo-Jo's entry into "polite" society began by visiting at my animal-assisted therapy group's board meetings. He progressed from tests for accidents and domination to a willingness to come with joy and pride when we called him. That convinced my husband and me that Mr. Jo-Jo's turnaround was genuine. Part of his evaluation included being "on" at an all-day pet fair. I recall an image of people, all sitting quietly while he ascended torsos, leaving kisses and a feeling of gentleness as he moved from lap to lap.

A scant two months after we got Mr. Jo-Jo, he became a registered therapy dog and has been visiting facilities ever since. His "love bug" position is curling up on a patient's bed, always with permission, or being held by me well within reach of weakened limbs that want to tousle his head or smooth his ears. Dubbed a gift on loan from God, our lab-dog-turned-therapy-dog is proof that all living beings have value.

Stephanie Morris Girton is a full-time music teacher, church music director, and author. She devotes her spare time to sharing her music and the unconditional love of her dog, Mr. Jo-Jo, with those less fortunate by visiting convalescent, retirement, and assisted-living facilities.

Facts about Animals in Research

World Week for Animals in Laboratories (WWFAIL), a project of In Defense of Animals, is an annual series of events occurring in April which seeks to educate the public about the moral and economic implications of vivisection, the use of animals in experimentation.

Did you know...?

- Each year, an estimated 30-60 million animals are used in laboratory experiments.
- Mice, rats, and birds make up 90 percent of all animals used in U.S. laboratories today.
- Because rabbits are inexpensive, readily available, and easy to handle, they are used extensively in product testing, especially for eye irritancy tests, commonly called the "Draize Test," named after the scientist Dr. John Draize.
- Beagles, because of their size and friendly nature, are the most common breed of dog used in research.

How You Can Help Animals in Laboratories

There's no doubt you care a great deal for your own companion animal. Now, consider how you'd feel if another precious creature, through no fault of his own, found himself in a laboratory where he was subjected to needless experiments in the name of beauty or education. Would you be willing to spend a little extra time shopping for cruelty-free products or taking a class that didn't use animals as learning tools so this animal could be set free and enjoy a life free of pain and suffering?

People for the Ethical Treatment of Animals (PETA) has a great motto which you may wish to adopt for your own life: "Animals are not ours to eat, wear, perform experiments on, or use for entertainment."

5. Objection to Dissection

"We must combat society's indoctrination that portrays animals as things without rights. We must make young people aware. It's surprising what they can do with the right information. They are our future."

—Sandy Larson, Humane Educator

Speaking Up for Compassion
by Nancy Schnell

As a University of Missouri student in the late 1960s, I refused to participate in a dissection exercise. I was punished for my compassion by receiving an "F" in the class. What's more, my professor—convinced that my feelings were related to unresolved issues about death—urged me to see a psychiatrist.

Not realizing at the time that there were others who felt the same way, I eventually gave in to the pressure of participating in dissection. Years later, as a middle school science teacher, I had my own students dissect preserved specimens of earthworms, fetal pigs, and perch.

One day, I witnessed students in another teacher's class killing frogs in preparation for their dissection exercise, and I experienced a profound reconnection to my feelings of compassion. I vowed never again to teach dissection, and because my school district did not mandate the practice, I was able to easily eliminate it from my curriculum.

For me, it was a wonderful new beginning to my life, as I was finally able to reconcile my identity as an animal advocate and my

identity as a teacher. I developed with one of my fellow teachers a Saturday morning workshop for students, parents, and other teachers to learn about alternatives. Today, I am a frequent speaker at regional and national teachers' conferences.

Thirty years after my professor urged me to see a psychiatrist, the University of Missouri has invited me back to speak to biology students on issues of ethics and compassion.

Nancy Schnell is a Missouri middle school teacher. In 1998, Ms. Schnell was awarded the Humane Educator of the Year Award from the Humane Society of Missouri.

Choosing a Non-Violent Education

October 1st marks the first day of Cut Out Dissection Month, a month-long event started by People for the Ethical Treatment of Animals. It's becoming easier to say no to dissection or experimentation on animals. Students around the world are declaring their right to a non-violent education that doesn't violate their ethical principles.

Did you know...?

- Dissection was first introduced into U.S. school curriculums in the 1920s.
- Every year, 5.7 million animals are used in secondary and college science classes. Frogs are the most frequently used animal. Other species include cats, mice, rats, worms, dogs, rabbits, fetal pigs, and fish.
- Many countries, including Argentina, Denmark, Norway, the Netherlands, and Switzerland, have banned school dissection. In America, states such as California, Florida, New York, and Pennsylvania have enacted laws giving students the right to refuse to dissect.
- Many actors like Alicia Silverstone (*Clueless* and *Batman*) speak out regularly against dissection.

If you are a student, you have a wonderful opportunity to stand up for the animals by choosing not to participate in classroom assignments that involve dissecting animals.

You can begin to learn more about dissection alternatives by reading the books on dissection listed in the Resources section at the end of this book or by visiting these Web sites:

National Anti-Vivisection Society:
www.navs.org/educate.htm

PETA Kids: Cut Out Dissection:
www.peta-online.org/kids/disindex.html

6. Being Kind to Animals

*"If man is not to stifle human feelings, he must practice
kindness toward animals, for he who is cruel to animals
becomes hard also in his dealings with men. We can judge
the heart of man by his treatment of animals."*

—*Immanuel Kant (1724-1804)*, Lectures on Ethics

A Cat's Gift to Us
by Dorothy Zammetti

Have you ever encountered a special animal in your life who stood
out above all the rest, who taught you a lesson of love and courage?
This is the story of just such a cat, a *king* among cats.

Chancey came into our lives in 1994 and although he only
stayed a short time, he left behind a legacy of boundless love and
understanding, of hope, courage and dignity.

Chancey was rescued from the streets after having been sub-
jected to unspeakable abuse by a group of uncaring youths. He was
a small cat, not quite six months old. He was brought into the vet-
erinary clinic where my sister worked as a technician. The doctor
did what she could to repair his injuries, tested him for the usual cat
diseases, and neutered and inoculated him. It was a lot to go through
for such a young cat, but he came through everything like a trooper.
The veterinary clinic tried to find someone to adopt him, but his
injuries caused his hind legs to be almost useless, so the prospects
of finding a home were next to impossible. My sister told me about
him, and something in my heart told me I needed that cat in my life.
So that same weekend, my family and I met a cat who brought with
him a gift so great that it has forever changed our lives.

Our First Look at Chancey

When he first arrived, my husband and I took one look at Chancey, and I cried. My husband, not a true animal lover but one who tolerated them for my sake said, "Oh, he's cute." The cat sat on the floor as a child would with his back legs straight out in front of him. He propped himself up on either side with his two paws. He was polydactyl, which means he had extra claws on both front paws, so when he held himself up, it almost looked as if he had hands that were flat on the ground. He stared at my husband and me as tears ran down my cheeks. When I moved closer to him, the little guy scooted away and dragged his back legs behind him. I was stunned to see how fast he could move. He dragged himself under the nearest bed and stayed there for quite awhile. Finally, I laid down by the bed and softly spoke to him.

I pictured myself holding him gently and kissing away his hurt. I asked him to please give us a "chance" to love him and take care of him. I held out my hand, and he slowly inched his way out from under the bed, gave my hand a little lick, and started to purr. He rubbed his little head against my hand, and my heart was his. This little guy, after all the hurt and pain human beings had caused him, was willing to give me a "chance," hence his name. My husband on the other hand was not feeling the same things I was, yet. He thought this might be a situation we could not handle.

My husband was a man of little emotion. He didn't have a demonstrative family as he was growing up and emotions were something to be kept hidden deep inside. It was hard for him to openly show love, even to me. He was also not much of a conversationalist and many times, people thought he was just unfriendly. But that would soon change, thanks to our very special little cat.

Chancey Fit Right In

As the days turned into weeks, Chancey kept us in constant awe and amazement. He would not let his handicap stop him from doing whatever it was that he wanted. His courage and will to survive was boundless. We had two cats, Casey and Mushka, at the time Chancey arrived, and I had some fear that they might hurt

him or not accept him. I was wrong. They took to him right away. Of course, our little Chancey gave them no choice. He instigated games and wrestling. We sat in amazement and watched a little cat with hardly any hindquarter control drag himself around the house at breakneck speeds.

He wrestled and played and did almost everything the other two cats did. He could not jump up onto any chairs, sofas, or windowsills like the other cats could. Watching the look of longing in Chancey's eyes must have opened the floodgates to my husband's heart. A look such as I had never seen before came over the man's face.

I can't describe the changes that took place in my husband after that, except to say it was some sort of awakening. I could have sworn I saw a tear in his eye. He was a changed soul.

Chancey's longing to do the one thing that his handicap prevented him from doing, kept my husband in the garage hammering and sawing for most of the day. He built Chancey custom ramps up to the sofa, chair, and windows. He beamed with pride at the way Chancey maneuvered up and down those ramps, now able to follow his housemates to the highest reaches of his domain.

Life went along so well for awhile. Chancey seemed to sense in my husband something that needed to be set free, so hubby and cat were almost constant companions. I would often hear soft whispering coming from one of the rooms, or gentle laughter, and I would find the two of them playing a game of "feather flyer" or "catch the catnip mousie."

Chancey Says Goodbye

After a while, I started to notice that Chancey was not feeling well. Our veterinarian ran some tests, and the results pointed to FIP or Feline Infectious Peritonitis. It was a very painful death sentence for our little boy. The vet explained that the disease was highly contagious to our other two cats, and it would cause Chancey great pain and suffering. Our sweet boy was in the final stages of the disease. So we looked deep into our hearts and made the decision to say goodbye and to send our sweet angel on his journey to a beautiful place.

I held that beautiful gift in my arms and said goodbye. I told him how much I loved him, as he drifted off to another place, with no pain, no aging, no cruelty; only beauty, light, and love. As he left this world, my husband took me in his arms and we cried a river of tears. Yes, my husband, a man who never showed emotion, openly wept real tears in the vet's office.

We stayed with Chancey for awhile, reassuring him of our love and thanking him for allowing us to come into his life.

Our lives have been enriched, thanks to Chancey. He showed a quiet, reserved man how to openly love. My husband and I have become even closer since his newfound love of animals, especially cats. He now helps me to trap, test, spay, and release the stray cats we find, and he has a much richer relationship with his children, both human and fur-kind.

Chancey has left behind a legacy of trust, companionship, courage, dignity and unbelievable love. A small cat entered our lives, but a king departed and left behind the greatest gift of all— the gift of an animal's unconditional love.

Don't shut your heart to that tiny meow you may hear in the distance, for it just may be the meow that can change your life.

Dorothy Zammetti is a school bus driver for special education children and full-time cat mom and animal lover. She volunteers as a community leader and chat host on America Online in the Pets Forum as well as on the Web for the Veterinary Information Network's Pet Care Forum.

Be Kind to Animals Week

"Humane Sunday" begins Be Kind to Animals Week every year in May. Be Kind to Animals Week was established by the American Humane Association (AHA) in 1915. A hundred years ago, according to the AHA, it was common opinion that animals were here for humans to use—and abuse—for our own gain. In 1877, several groups joined together to form the American Humane Association, whose goal is to be a voice for the animals.

For more information on Be Kind to Animals Week, contact:

American Humane Association
63 Inverness Drive East
Englewood, CO 80112-5117
(303) 792-9900
www.americanhumane.org

Did you know...?

- 72 percent of married couples who have pets greet their pet first when they get home. Thirteen percent say they greet their spouse or significant other first. Seven percent first greet their kids.
- Approximately 95 percent of people with pets have a photo of them on display in their home or office. Of these, about 30 percent keep their pet's photograph in their wallet.
- Almost 50 percent of the people surveyed said their pet sleeps in their bed more often than on the floor or the couch.
- Over 80 percent have given their pets special treats.
- According to the American Animal Hospital Association, almost four out of ten pet caregivers (39 percent) spend three or more hours of quality time with their animals every day.

Be Kind to Your Companion Animal

What have you done today to show your companion animal how much he or she means to you? Have you spent some "quality time" together just stroking your cat or throwing a tennis ball for your dog? The next time you take your dog for a walk, let him take his time sniffing the ground and the bushes. This may be the only time all day when he gets outside and he would love to socialize with you and other dogs. And a few minutes spent combing your cat's fur or throwing a catnip mouse can mean the difference between a bored, unhappy feline and a relaxed, happy one.

7. Adopting an Animal Companion

"We need a boundless ethics which will include animals also."

—Albert Schweitzer (1875–1965)

Jellybean
by Julie Ann Mock

At the end of last summer, a black male kitten escaped from the Animal Shelter Assistance Program (ASAP) facility. We set out a humane trap and caught him the next day. He was named "Houdini" in honor of his supposed jailbreak. In the unfamiliar surroundings of the shelter, he became more and more frightened and hard to handle. My husband and I agreed to become foster parents to this shiny black kitten with the gorgeous green eyes.

I renamed him "Jellybean" because the word had such a positive and carefree connotation. I kept Jellybean in a big cage in a very large bathroom. A riding crop served as an extension of my arm, as he was more comfortable being touched from a distance than directly.

Jellybean seemed so lonely and desperate for companionship, yet the day when he'd be comfortable with people seemed very far away. Thinking he might enjoy spending time with another cat, I tried introducing him to my black cat Melanie, but she quickly let me know she was not interested in babysitting. Despite her lack of enthusiasm, Jellybean's reaction was immediate and very touching. The minute he saw her, he began chirruping and rolling around in his cage, nearly turning himself inside out just to get close to another cat.

Jellybean's lot in life was improving rapidly. He liked to play

with the riding crop and other toys. Now, after a brief warm-up period, he was beginning to offer himself up for petting as well. With each step he took toward trust, the wall of fear crumbled, revealing a happy, gentle, joyful soul. He would sit in the middle of the room and just purr with the sun shining on his glistening black coat. When I think of Jellybean today, I picture him sitting in that sunlight, radiating contentment and well-being.

Jellybean's Future

Meanwhile, some important decisions needed to be made with regard to his future. Should I keep him longer to see whether he could make more progress toward being a completely comfortable people-cat or should I try to find an understanding adopter to take him the rest of the way? The bathroom is fine as a transitional residence but is no substitute for a real life in a home with a permanent family. I decided to try featuring him as one of the cats in our year-end appeal letter in which we include several stories of ASAP cats. I wrote that Jellybean would need a special home with people who understood his background and were willing to continue working with him, deliberately leaving out my name and phone number. I felt that someone, who was truly up to the Jellybean challenge, should be willing to take the initiative of finding out where he was.

Not really expecting a response, I was surprised to receive a call from Yvonne, the mother of Le Ann, a 24-year-old young woman who was developmentally disabled. It seemed Le Ann had read the letter and been drawn to the story of Jellybean. Through her own experiences in a world that rarely pauses to allow for those who speak, move, or think more slowly, she could relate to Jellybean's problems of being different, fearful, and misunderstood. "That's my cat," she told her mom.

Le Ann turned out to be not only someone who was highly motivated to work with Jellybean, but a capable "cat whisperer" as well. Yvonne says that Le Ann is often the only person in the room a scared cat will have anything to do with. When she and Le Ann came to visit Jellybean, they found him to be the same cat

described in the letter, and although he was still skittish, they instantly fell in love with him.

I hadn't heard from Jellybean's new family in several months, when Yvonne called one day. I couldn't have been more pleased by what I heard. After several months of allowing Jellybean to be the cat king of the house, they adopted a grey kitten for him, and, as expected, Jelly is absolutely delighted with Smokey. Jellybean now weighs fourteen pounds and is beloved by all who know him. Le Ann is still the only one who can easily handle him, but he plays with, amuses, and is enjoyed by everyone in the family. Yvonne says that Le Ann's considerable accomplishments with Jellybean continue to be a source of pride and satisfaction for all family members but most notably for Le Ann herself.

She has made all the difference in his life, and he has left an indelible paw print on hers.

Julie Ann Mock is a lead volunteer at the Animal Shelter Assistance Program (ASAP) in Santa Barbara, California. Her story of an unwanted shelter kitten and a developmentally disabled young woman shows us that everyone has something valuable to offer.

Adopt a Shelter Animal

In June, animal shelters across the country observe National Adopt a Shelter Cat Month. If you're thinking of adding a feline companion to your family, June is an ideal time to do so because many shelters offer low or no cost adoption fees that may also include spay/neuter and vaccination costs.

In October, animal shelters observe National Adopt a Shelter Dog Month which seeks to create awareness of all the wonderful purebred and mixed breed dogs awaiting new, loving homes.

The first week in November is National Animal Shelter Appreciation Week. It is sponsored by The Humane Society of the United States and seeks to educate the public about the important contributions animal shelters make to the community in which they live.

Adopting an animal companion from a shelter will change your life *and* theirs for the better.

Did you know...?

- Only two out of ten kittens born in the U.S. ever find a life-long home.
- Every day in the United States, 40,000 puppies and kittens are born.
- For every child who is born, four puppies and kittens are also born.
- 25 percent of all dogs entering shelters each year are pure-breds.
- The San Francisco Society for the Prevention of Cruelty to Animals (SF/SPCA) is a model shelter for the rest of the country. Touted as the first no-kill shelter in the nation, the San Francisco SPCA has been successful with many innovative programs to help ease the pet overpopulation problem.
- Nearly half of all U.S. households have pets, but only 15 percent are from animal shelters.
- Caregiver relinquishments account for almost 30 percent of all animals entering shelters. "I'm moving" is the number one reason for dogs and number three for cats.
- Housing related problems account for almost two-thirds of the adoptable dogs in shelters.
- Morris the Cat, TV spokescat, was adopted from an animal shelter in the late 1970s.

Making an Animal Shelter More Inviting

Have you visited your local animal shelter or humane society lately? Is it an inviting place where people like to come and volunteer their time or choose an animal awaiting adoption? Can it use some sprucing up?

There are many creative ways you can help make animal shelters more inviting to prospective adopters:

- Consider purchasing a couple of nice houseplants and give them to the shelter to place in their front office.
- Offer to rake up the leaves that have fallen from a nearby tree or plant a few flowering bushes.
- Volunteer to help walk large dogs and play with them so

they are friendlier when prospective new families come to look at them.

- Offer to clean the litter boxes in the cat room.

Even a few minutes spent at the shelter can make a difference for the overworked staff and the animals awaiting a new home.

8. Helping to Reduce Pet Overpopulation and Pet Theft

"I ask for the privilege of not being born...not to be born until you can assure me of a home and a person to protect me, and a right to live as long as I am physically able to enjoy life...not to be born until my body is precious, and men have ceased to exploit it because it is cheap and plentiful."

—*Author unknown*

Bringing Tang Home: One Feral Kitten at a Time, Volunteers Care for the Wild Ones
by Gina Spadafori

In the warm half-light at the end of a summer day, the woods near my home fall quiet as if holding their breath waiting for the wild creatures of the night. Twilight is nature's shift change: In an hour's time the day will be gone and night will be filled with the furtive rustlings of animals who'd rather their comings and goings be unnoticed by the residents of the nearby houses.

I let my own breath out slowly, quietly, for I am also waiting, as is the woman beside me. The night creatures we wait for, though, aren't meant to be wild. We are waiting for cats.

Among the Wild Things

The opossum, the raccoon, and the skunk steal food from their human neighbors on the other side of the river levee but want nothing in the way of affection. They flee from the sound of footsteps and bare formidable teeth if cornered. "Approach at your peril!" they snarl before melting into the shadows.

But the cats aren't quite so anxious to run. Perhaps this is because their kind and ours have been linked for countless generations, or perhaps it is because, among all the animals, cats alone chose the path of their own domestication and remember it still. Whatever the reason, in the heart of these cats—of every cat gone feral—remains a memory of how pleasant is the company of a human, of how sweet is the feel of a hand swept warmly from just behind the ears and along the supple spine to the end of the tail.

My companion tonight is one of those people who work to return the wild ones to a life of such pleasures. The cats in these woods belong to her, as much as they belong to anyone. She traps the older ones and has them fixed and vaccinated before releasing them to these woods again, for they are too wild to be good pets. The kittens—for despite all the spaying and neutering, there are always new cats, and so, new kittens—she traps and tames, and finds homes for.

We are after the last of the spring kittens this night, a pale orange tabby male she has named Tang (as in orange Tang). The older cats know what the trap is about, and only the most desperate starvation would lure them inside again. The kittens aren't so world-wise. The appeal of canned food is enough for them, and all but Tang have already been enticed inside for the first step on their journey back to domestication.

The Task of Taming

In the dimming light we can barely see the half-grown kitten move inside. The trap slams shut with a crack that scatters the cats—all but the young tabby who now cannot flee. He hurls himself against the sides of his cage, yowls in fear, and hisses in anger.

The sound beside me is no less explosive. "Yes!" cries my companion. "We got him!"

Tang doesn't yet know it, but he is on his way home. After a few weeks of gentle and gradual socialization, he'll be placed with someone who'll love him. A better fate, surely, than the one he faced as one of the ferals, whose short lives are full of desperation—and often end brutally.

Despite the dangers that claim so many, wild cats are everywhere on the edges of our lives, from the alleys of our cities and the parks of our suburbs to the wild areas and farmland that fill the gaps in between. And in many of those places are people like Tang's captor, quietly pursuing a labor of love that can be as thankless as it often is controversial. Some people would rather see the ferals killed, but these volunteers see another way.

One kitten, one spay, one summer evening at a time, they are making a difference. Few thoughts are as pleasant to contemplate as the summer night hugs me in a warm embrace.

Gina Spadafori is the author of the popular Dogs for Dummies, Cats for Dummies, *and* Birds for Dummies *books. She also writes a nationally syndicated newspaper column on pets and is affiliated with the Veterinary Information Network, an online service for veterinary professionals.*

Spay and Neuter Animals

"Prevent a Litter Month," a program of The Humane Society of the United States, is observed by animal protection organizations nationwide in February. Millions of animals are killed each year simply because there aren't enough homes for them all. Prevent a Litter Month seeks to increase awareness of the pet overpopulation problem.

In 1992, Homeless Animals' Day was created by the International Society for Animal Rights. The third Saturday in August is observed to publicize the dog and cat overpopulation problem.

Pet Theft Awareness

On February 14th (Valentine's Day), we also observe Pet Theft Awareness Day. Thousands of our companion animals are stolen from cars and their own backyards each year and are sold to research laboratories or illegal dog-fighting rings. Whatever your view is on animal experimentation, most would agree that experimenting on an animal who was a stolen pet is off-limits.

Each year, Last Chance for Animals coordinates efforts to

bring pet theft to the attention of the media and elected officials across the country. For more information, contact Last Chance for Animals at www.lcanimal.org or by calling (310) 271-1890.

Did you know...?

- Contrary to popular belief, feral cats are not the main reason for the decline in the world's bird species. According to a 1994 World Watch Institute study, the four primary reasons are: habitat loss, overtrapping, drought, and pesticides.
- Every year, six to eight million dogs and cats are killed in our nation's shelters.
- One dog and her offspring can produce 67,000 dogs in six years.
- One cat and her offspring can produce 420,000 cats in seven years.
- Of the nearly twenty fatalities caused by dog attacks investigated between 1992 and 1994, none were caused by a spayed or neutered dog.
- Ten million stray and abandoned companion animals die on our streets from abuse and neglect every year.
- Maddie's Fund is an organization started with a $200 million donation from Dave and Cheryl Duffield, founders of PeopleSoft in San Francisco. Its president is Richard Avanzino, the former president of the San Francisco SPCA. The mission of the Fund, according to its Web site is "to revolutionize the status and well-being of companion animals." In carrying out this mission, Maddie's Fund intends to help build, community by community, a No-Kill Nation.

 For more information on the San Francisco SPCA and Maddie's Fund, visit their Web sites at:

 San Francisco SPCA: www.sfspca.org

 Maddie's Fund: www.maddies.org
- Nearly one out of every five dogs in the United States will be lost or stolen this year.
- Only 4 percent of lost cats who enter U.S. animal shelters are returned to their guardians.

- Many celebrities such as screen legend Tippi Hedren, Olympic gold medalist Greg Louganis, and *Exorcist* star Linda Blair have lent their name and voice to the issue of pet theft.

Make a Difference in Pet Overpopulation and Pet Theft

You have the power to make a tremendous difference in the pet overpopulation problem simply by having your own pet spayed or neutered. (Remember, six to eight million dogs and cats are killed in the U.S. every year.) According to the 1990 U.S. Census, the state of Georgia had 6,478,216 residents, and New York City had 7,322,546 residents. So each year in our nation's shelters, the number of homeless and abandoned animals who are put to sleep is equal to the entire population of Georgia or the entire city of New York!

According to John Keane (a.k.a. Sherlock Bones), an authority in the field of pet retrieval, more than 90 percent of pet caregivers recover their pets within ten to twenty blocks from where they were reported missing. The reason most pets are found in this target zone is that lost animals do not travel in a straight line. They circle the area and have been found weeks later within two miles of where they were lost. Even if your pet was stolen, the petnapper is usually local. John Keane's book, *Sherlock Bones* is devoted specifically to the recovery of lost or stolen pets. Check your local bookstore or library for the book and visit the Sherlock Bones Web site at www.sherlockbones.com for more information on what to do if you believe your pet has been lost or stolen.

9. Farm Animals Need Your Help

"Widen our circle of compassion to embrace all living creatures and the whole of nature in its beauty."

—*Albert Einstein (1879–1955)*
Time *magazine's Person of the Century*

Hear No Evil, Neigh No Evil
by Kristi Littrell

"If only animals could talk!"

I've heard so many people say this about their sick dog or problem cat, or even a pet who has such a peculiar trait that you just know it can be traced to their history. "If only they could just tell me...."

It's the same here at the Best Friends Animal Sanctuary.

Recently, while I was out feeding the horses their morning buckets of breakfast, I leaned over to hand Brownie, a twenty-five-year-old quarter horse gelding, his food.

Unlike the other horses who swipe bitefuls here and there from each others' pails, Brownie patiently waited for me to set his down in front of him. Then he stared at me with his dark appreciative eyes and nodded at me before beginning to eat. This is our "Fuzzy Bear's" (as Brownie is affectionately nicknamed) way of saying thank you. Since his arrival here only two short months ago, it is a daily courtesy that he extends to whoever offers his meal.

His gentle manner and ability to communicate his appreciation so clearly engenders special care from us all. As he eats, we keep guard over his bucket, protecting his rations from the other horses who might take advantage of his giving nature to sneak a bite.

I wish Brownie could tell us his life story. How did he come to be living behind the restaurant where we found him? With his sad face and protruding ribs (he was severely malnourished and in poor health), he was the "star attraction" at a Western-themed eatery near one of the National Parks which was there for patrons to pet and feed carrots and apples to the animals.

Nobody seemed to be paying much attention to Brownie.

Four of us from the Best Friends staff had just dropped in for a meal when we saw Brownie. There he was, standing forlornly off to the side near the outdoor tables. The moment we saw him, we knew we had to get him out of there.

We walked over to study him more closely and offered him our small donation of an apple. Instead of hungrily ripping it out of our hands, as one would expect, he gingerly took only a small bite.

Then, turning his head to examine us, a scarred and cloudy eye met our own eyes. When we began to walk away, he nuzzled all of us once more, asking for help soon.

When we questioned the restaurant owner about Brownie, we received an offhand response that the horse was bought for $600. The "owner" hoped to break even by sending the old horse to slaughter the next week.

With all of our hearts aching for this lonely, neglected animal, we offered to give the horse a good home at the sanctuary for the rest of his life, however long that may be. But the man declared that one should never give away "property" for nothing in return. He wanted $100. We gladly gave him this amount for, as far as we were concerned, this horse was priceless. Delighted with our rescue, we loaded him up on the spot and carried a grateful Brownie back to the sanctuary.

The Brownie Rescue Mission

The next day, Dr. Allen gave Brownie his first checkup. He was blind in his right eye due to a prolonged, untreated eye infection. Worse, the infection had spread throughout his head, and as a result, he was also deaf. Adding to his health problems, Brownie was at least 300 pounds underweight and badly needed dental work.

There was a small chance, Dr. Allen asserted, that Brownie could regain his sight and hearing with strong antibiotics and lots of TLC. This was a chance, no matter how small, that all of us at the horse stables vowed we would make a reality.

The Brownie Rescue Mission began in earnest the next day. Brownie got a dental treatment and began a course of intensive antibiotics administered in his Equine Senior diet, along with supplements added to help him gain weight.

He also needed antibiotic ointment in his bad eye. Always approaching him from his good side so as not to startle him, we would place the thin line of ointment in his eyelid while Brownie stood perfectly still, not even blinking. He was the perfect patient, obviously aware that he was in a different place, that he was being cared for.

After the treatment and his obligatory thank you, Brownie would begin eating. With each biteful, he would glance up with a deep look of appreciation. He knew we had saved him and would never forget it.

Ready for a New Home

Now three months later, Brownie is ready for a new home. The special care he's received has cured virtually all of his health problems. His hearing has been restored. He's round and plump now at a good weight, and surprisingly, he even has some sight in his right eye.

There's no doubt that Brownie is our angel among the horses. He never steals food from his friends' buckets. He gets along with everyone and always bestows a look of love on each of his caretakers. Our "Fuzzy Bear" never saw or heard the ill will that was cast on him, yet he undoubtedly felt it. But like many animals, he forgave it all and doesn't hold his past neglect against the human race.

Despite all he suffered, he genuinely loves and neighs no evil.

Kristi Littrell is Associate Editor of the Best Friends Animal Sanctuary *magazine. Best Friends, located in Kanab, Utah, is the nation's largest sanctuary for abused and abandoned cats, dogs, and other*

animals, with never fewer than 1,800 animals in residence. Inheriting her deep love for animals from her parents, Keith and Bev, Kristi shares her home with her dog Frosty and various other beloved critters.

For Love of Farm Animals

National Farm Animal Awareness Week was founded in the early 1990s by The Humane Society of the United States (HSUS) to promote awareness of and dispel misconceptions of farm animals.

Farm animals have complex natures and fascinating behaviors. Were you aware that pigs love to bowl? And chickens know how to ballroom dance? According to the HSUS, pigs enjoy playing with bowling balls and old tires, as well as other toys. And when a rooster and hen are courting, they dance around each other in a ritual referred to as "waltzing."

Did you know...?

- Factory farming (the modern practice of raising livestock in crowded, indoor warehouses) is responsible for the deaths of billions of animals every year. In addition, factory farming is also responsible for the pollution of rivers, soil, and groundwater because of its high output of manure and other waste.
- Factory farming uses more natural resources than any other industry—more than one-third of all raw materials and fossil fuels in the United States.
- Laying hens have a well-developed nervous system and are sensitive to touch, temperature, and pain. Even their beaks have nerve tissue and pain receptors.
- 77 percent of voters are concerned about the humane treatment of factory farmed animals and 66 percent of voters are likely to support a candidate for public office who will crack down on pollution from factory farms.

Helping Farm Animals

Have you ever visited a traditional animal farm? Did you have the opportunity to spend some time getting to know the animals? Farm animals are very social creatures. When you discover how intelligent and friendly they can be, you realize how unkind it is to force them to live and die on factory farms.

You can help make a difference for farm animals in a variety of ways. Begin by educating yourself, your friends, and your family. Become aware of where your food comes from. A good place to learn about farm animals is on the Internet. The Humane Society of the United States (HSUS) has a Web site which will help you learn more.

For more information, visit the HSUS Farm Animals and Sustainable Agriculture page at www.hsus.org/programs/farm/index.html. There is also a list of books on factory farming in the Resources section at the end of this book.

10. Vegetarianism and Veganism

"If you love animals called pets, why do you eat animals called dinner?"

—*Farm Sanctuary slogan*

Emily the Cow

"Emily is no ordinary cow," reported the local papers. No, ordinary cows don't have names. Newspapers don't feature articles about them. Communities don't band together to save them. So what made Emily special?

Emily spent most of her short life on a dairy farm but, despite repeated attempts at artificial insemination, she never became pregnant. There is no room for a barren cow on the milk production line.

One cold New England morning, Emily was loaded onto a truck. Soon she found herself in a holding pen at a slaughterhouse. Surely, she recognized danger.

Freedom beckoned from beyond the five-foot fence. Thinking only of escape, the brave bovine hurled her 1,400-pound frame over the barrier and fled for her life.

For weeks, the slaughterhouse workers tried to capture Emily, but she had learned to fear humans. Somehow, she managed to conceal herself in the backwoods, foraging for what little food she could find. Local residents heard of her plight and formed an "underground railroad," leaving bales of hay in the woods and refusing to report sightings of her to officials.

When Meg and Lewis Randa heard about Emily, they knew they had to help her. Their farm was already home to rescued

horses, goats, rabbits, and dogs, and they determined that there was also room for a needy cow. They contacted the slaughterhouse owner who agreed to sell the troublesome missing animal for $1.00.

The Randa family, assisted by an army of local supporters, set out to rescue the frightened cow, using succulent morsels of food and gentle coaxing voices. For days, she watched her rescuers but eluded them. Then, on Christmas Eve, a weak and thin Emily decided to trust again. She walked into the Randas' borrowed trailer and found herself being driven to her new home. The next day, Christmas dinner, featuring a delicious vegan stew and top grade hay, was served in the barn to all the guests, including Emily.

The Randas say Emily has developed a fondness for bread, likes to have the top of her head scratched, and loves to kiss her new friends with her big cow tongue. People visit and bring her gifts, some leaving messages of love and contrition pinned to the barn and the fence.

One read simply, "I used to eat cows. I'm sorry. No more."

In 1995, Emily the cow was adopted by vegetarians, Meg and Lewis Randa. She now lives at the Veganpeace Animal Sanctuary at the Peace Abbey in Sherborn, Massachusetts. She has gained national media attention, including a full-page profile in People *magazine. A motion picture and a book about Emily's story is in the works.*

Finding Alternatives to Meat

The Great American Meatout Day is the world's largest grassroots dietary education campaign. Thousands of people across the United States and Canada mark March 20, the first day of spring, by abstaining from the consumption of meat. For more information on the Great American Meatout Day, contact:

Farm Animal Reform Movement (FARM)
PO Box 30654
Bethesda, MD 20824
1-800-MEATOUT
www.meatout.org

Did you know...?

- Twice as many women as men are vegetarians.
- In 1996, nearly 1.4 million Americans died of diseases (such as coronary and rheumatic heart disease, cardiovascular disease, stroke, and high blood pressure) linked to consumption of meat and other animal products. But not one death was linked to consumption of grains, vegetables, and fruits!
- One in five restaurant diners looks for vegetarian meals when eating out, and one in three orders a vegetarian entrée if it is on the menu.
- Meat production in the U.S. uses more than half of all water and 33 percent of all the raw materials used for all purposes. It takes 2,500 gallons of water to produce a pound of meat, but only 25 gallons to produce a pound of wheat.
- According to the "Unified Dietary Guidelines" developed by some of America's top health organizations, you'll be healthier by eating a variety of foods and choosing most of what you eat from plant sources.
- United States livestock eat enough grain and soybeans to feed over five times the number of people in the U.S.
- Chris Campbell, two-time Olympic wrestler, won a medal at age thirty-eight on a vegetarian diet.

Becoming Healthier Through Your Food Choices

People, young and old, are becoming more conscious of their own good health and the health of the planet and its many animal inhabitants.

You have a wonderful opportunity to make a positive impact on your health by choosing a more plant-based diet which may include beans, rice, soy, and legumes. By continuing this practice over a period of time, you will begin to feel better physically and be rewarded with the positive feelings you get in knowing you are making a difference for the animals.

11. Make All the Holidays Cruelty-free

"An animal is for life, not just for Christmas!"

—Bumper sticker

I Am Thankful
by Kenneth White

Although I'm not especially committed to any particular holiday, Thanksgiving has long been my personal favorite. It's not the food, not the parade, not the family gathering, nor the autumnal colors. It's not the pre-Christmas shopping sales, nor the long weekend filled with good leftovers. It's something far more basic than any of that.

I try, every day, to remember the many good things in my life. I am thankful for my work, for the opportunity to make a difference in the lives of animals and the people who care about them, to find my livelihood in my passion. I am truly thankful for the chance to know, to work for, and to help animals.

I am thankful for the soft, warm curve of a dog's face nestling in an open hand. I am thankful for the rich smell of their fur. I am thankful for the conversations with dogs, so often beginning with a calloused paw touching a shoulder. I am thankful for the roughhouse play, the chase, rolling together through grass and dirt, lots of legs flying, and then sitting together afterward, quiet, being loved by those chocolate eyes. I am thankful for dogs.

I am thankful for the intelligent stare of a cat's eyes, direct and unblinking into my own, impossibly beautiful green or blue or yellow eyes that stare without question or comment, just seeking connection. I am thankful for the electric touch of that small, lithe

frame. I am thankful for the soundless conversations with cats, the lengthy, silent, late night talks. I am thankful for the way they nestle around my body, making blankets of themselves. I am thankful for cats.

I am thankful for the relationships that all of us human animals can have with the Earth's so many other animal inhabitants.

Kenneth White is Executive Director of the Arizona Humane Society in Phoenix, Arizona. His story is a wonderful reminder to all of us to give thanks for the animal companions in our lives.

Truly Celebrating Holidays

The various holidays we celebrate each year are times to remember our animal friends. So often, the bunny impulsively purchased for a child at Easter or an exuberant puppy adopted as a Christmas gift quickly becomes a burden and nuisance when the novelty wears off.

Let your holiday shopping and food choices be statements of compassion toward all creatures. Instead of feasting on the traditional fare of turkey and stuffing at Thanksgiving, try a "Tofurky," a meatless turkey alternative, available at most grocery stores.

Or adopt a "virtual" turkey from Farm Sanctuary. Beacon and his other turkey friends were rescued from a turkey hatchery where they were destined to be raised for a Thanksgiving dinner. After saying "No, thanks" to this tradition, the turkeys and people at Farm Sanctuary decided to start a new holiday tradition.

Every Thanksgiving, they encourage people to save, rather than serve, a turkey by adopting one. By sponsoring a turkey like Beacon, you help provide lifelong care for rescued turkeys; and the shelter turkeys do their part by teaching the public to be kind to all animals by not eating them.

Go to www.farmsanctuary.org for information on virtually adopting your own turkey.

Few people do not know the story of the infant born in a stable one night in Bethlehem. What you may not know is that the popularity of the Nativity scene, one of the most beloved and

enduring symbols of the holiday season, originated in Italy. St. Francis of Assisi, the patron saint of the animals (1181-1226) asked a man named Giovanni Vellita of the village of Greccio to create a manger scene with various animals. St. Francis performed Mass in front of this early Nativity scene which inspired awe and devotion in all who saw it. The re-creation of the nativity scene is a tradition that continues around the world today.

Did you know...?

- Of all the holidays, Christmas is the most popular for pets. 98 percent of pets participate in Christmas.
- About 80 percent of women who have dogs or cats give them gifts on holidays or other special occasions.
- Before adopting an Easter bunny, consider that a well-cared-for spayed or neutered house rabbit has a life expectancy of eight to twelve years.
- More than half of all dogs and cats in the United States receive gifts on Christmas, for their birthday, and on other holidays.
- Consumers spend $22 billion dollars a year on pet food and supplies such as pet clothing, leashes, toys, collars, books on pets, food dishes, beds, and scratching posts.
- 70 percent of people with pets hang stockings for them at Christmas and 24 percent send a Christmas card to or from their pet.

Show Your Companion Animal How Much You Care

Any holiday is an ideal time to reflect on just how important your companion animal is to you and your family. He or she provides you with unconditional love all year long. Why not show him just how much you care by giving him a gift you know he'd love or spending some quality time bonding with your pet?

II.
68 Tips for
Living a More
Compassionate Life

12. Quick and Easy Ways to Help Animals

"We cannot talk with animals as we can with human beings, yet we can communicate with them on mental and emotional levels. They should, however, be accorded equality in that they should receive both compassion and respect; it is unworthy of us to exploit them in any way."

—*Rebecca Hall,* Animals Are Equal

Creatures of the Universe
by Ann Winter
Animals bring to us a love not often found in humankind.

Theirs is a love of unspoken warmth, companionship, and tenderness.
Theirs is an unconditional love, born out of trust and loyalty.

Each has a special place in the cycle of life.
Whether fur, feather, quill, scale, skin, or hide,
Their existence is essential to the balance and continuation
Of harmony in our universe.

The comfort we receive from earthly creatures is soulful,
And at times, heavenly.

The bond between animals and humans is one not easily broken.
Even in death,
Beloved animals stir love, comfort, and fond memories.
We can learn so much from the simple lives and love of animals.
Let us always remember to hold them firmly in our love,
As they hold us firmly in their trust.

Ann Winter is a poet and free-lance writer living in Santa Barbara, California. Her poem gently reminds us all of the immense value animals bring to our lives.

Quick and Easy Tips

Do you know that, in just *one minute*, you can make life a little better for the animals? Many of the tips in this chapter cost no money and take only a minute or two to do. But, what a difference you can make! Read through this chapter and select one or two of the tips to do this week. See just how easy it is.

Cut six-pack rings Plastic six-pack holders are plentiful in dumps and landfills and are almost invisible underwater where countless birds and other wildlife are killed or injured every year by becoming entangled in the holders. Before you throw out the six-pack holders from your soda or beer, snip each of the circles with scissors. Whenever you see a six-pack holder lying at the beach or elsewhere, snip the circles before discarding it.

Discourage wild animals naturally There are several simple things you can do to humanely discourage deer, raccoons, opossums, coyotes, and other wildlife from your yard. Take in outside pet food and water dishes every evening, and securely cover your garbage cans (with bungee cord if necessary).

Pick up fallen fruit Fruit which has fallen from a tree is an easy meal for wild animals. Simply pick up the fruit to discourage animals from your yard.

Keep your dog with you at all times When shopping in a mall or eating in a restaurant, you'll notice people often leave their dog tied outside. This is an easy opportunity for a "buncher" (a person who collects and sells animals for profit) to steal your pet. These animals are often sold to research laboratories or to illegal dog fighting rings. If your dog can't stay with you at all times, he's safer remaining at home.

Eat healthy convenience food Try a bean burrito from Taco Bell; it doesn't contain meat or lard, an animal by-product. Or try the Dilberito, invented by vegetarian Scott Adams (creator of the

"Dilbert" comic strip). The Dilberito (www.dilberito.com) comes in four flavors and is available in most major grocery stores.

Watch a video In the video *Diet for a New America: How Your Food Choices Affect Your Health, Happiness and the Future of Life on Earth,* John Robbins, son of the founder of the Baskin-Robbins ice-cream empire, shows how an animal-based diet is adversely affecting human health. Abandoning the wealthy lifestyle of his family, Robbins lived in a log cabin while subsisting on a simple diet of grains. He eventually realized his calling as a dietary evangelist. John Robbins also wrote a book by the same title as the video.

Join a newsgroup or mailing list If you're on the Internet, there are thousands of places you can go to learn more about animal protection. A few places to start are:

The Inter-Campus Animal Advocacy Network (I-CAAN) is a project of The Humane Society of the United States linking college and high school animal activists and groups everywhere to help them share ideas and strategies, recruit members, carry out campaigns, and help animals. For a free subscription to I-CAAN, send an E-mail message to waste@waste.org with the words "subscribe icaan" (without the quotations) in the body of the message.

HUMANElines is a free, weekly electronic alert of the hottest animal issues. The Humane Society of the United States creates and distributes HUMANElines to enable you to make a difference instantly. You'll learn about Federal legislation and dates when comments are due from the public to executive agencies on important animal issues. You'll be kept up to date on high-profile cruelty cases, big victories, and other significant events affecting animals. To subscribe, send an E-mail message to: subscribe-hsus-action@lists.hsus.org with the words "subscribe hsus-action" (without the quotation marks) in the body of the message.

For more information on The Humane Society of the United States and its other programs, contact:

The Humane Society of the United States
2100 L Street, NW
Washington, DC 20037
www.hsus.org/programs/research

Animal Rights Online (ARO) is the largest animal rights online newsletter on America Online, providing information on virtually any topic related to animal rights. ARO offers three free newsletters plus a book review and listings of animal rights, vegetarian, and animal welfare-related Web sites each week. To receive a sample newsletter, send an E-mail message to: EnglandGal@aol.com.

Animal Talk publishes a free newsletter which highlights rescue and placement of animals, animal cruelty and abuse issues, legislation affecting animals, and pet care alerts. To subscribe, send an E-mail message to: nyppsi@aol.com with the words "mailing list" in the subject line.

Become aware of poisonous plants Certain houseplants, such as amaryllis, begonia, calla lily, ivy, mistletoe, philodendron, and hyacinth can be toxic to your pets. Check with your veterinarian for a complete list of poisonous plants.

Observe your language You can help elevate the status of animals by referring to them as "he" or "she" instead of "it." Refer to yourself as your companion animal's "guardian" instead of "owner." In 1999, In Defense of Animals, a San Francisco, California-based animal rights organization, successfully lobbied the San Francisco Commission of Animal Welfare to amend city laws to include the designation "animal guardian."

And watch the clichés you use with reference to animals such as "bringing home the bacon," "killing two birds with one stone," or "taking the bull by the horns."

Changing our language and removing such clichés from our vocabulary will help shift people's attitude toward animals.

Visit a mobile adoption clinic Many shelters and humane societies around the country participate in mobile adoption clinics

where cats and dogs are showcased at a shopping mall or other location away from the shelter. This extra exposure increases an animal's chance of being adopted. For instance, PETsMART, a national pet supply retailer, helps find homes for thousands of homeless pets every year through its in-store PETsMART Charities *Luv-A-Pet* program. In addition, PETsMART Charities promotes spaying and neutering of companion animals.

To learn more about PETsMART Charities, contact:
PETsMART Charities
35 Hugus Alley, Suite 210
Pasadena, CA 91103
1-888-839-9638
www.petsmart.com/charities

Read a comic strip The *Mutts* comic strip was created by cartoonist Patrick McDonnell in 1994 and is currently syndicated in over 400 newspapers nationwide. *Mutts* features Earl the dog and Mooch the cat. McDonnell has worked with The Humane Society of the United States and the North Shore Animal League to create a special series of *Mutts* "Shelter Stories" strips to help raise awareness of the plight of animals in shelters and promote pet adoption. He also often partners with animal shelters and their mobile units to help local pets find homes during his book-signing appearances across the country.

Keep Fido and Fluffy at home Keep your companion animals safe at home on July 4th. Animals can easily become frightened by the noise of fireworks. Place them in a quiet room, perhaps with some soft music to mask the sounds of fireworks. Be sure they are wearing their collars and tags just in case they do escape and become lost.

Protect your animals from fire A fire is always dangerous, especially during the dry, summer months. If a fire broke out in your home while you were away, what would happen to your beloved pet? By putting a "Please Save Our Animals" sticker in your front window or on your front door, firefighters are better able to save precious lives. Stickers are available from People for the Ethical Treatment of Animals, 1-800-483-4366.

Leave your dog at home on hot days It's best to leave your canine friend at home rather than waiting for you in a hot car. Car temperatures on a hot day can rise to 160 degrees in as little as fifteen minutes, *even with the windows cracked open.* Signs of heat stress are: heavy panting, glazed eyes, deep red or purple tongue, dizziness, vomiting, and rapid pulse.

If your dog can't accompany you on your outing, he's safer and happier at home.

If your dog gets overheated, lower his body temperature immediately by doing the following:

- Move him into the shade and apply cool (not cold) water all over his body.
- Apply ice packs or cold towels to his head, neck, and chest only.
- Let him drink small amounts of cool water or lick ice cubes.
- Take him to a veterinarian right away; it could save his life.

You can also order an informational flyer titled *How Long Will You Be Gone?* to place on cars where a dog is left unattended.

Order the flyers from:

American Humane Association
63 Inverness Drive East
Englewood, CO 80112
(303) 792-9900
www.americanhumane.org

Attend a cruelty-free circus In the summer, traveling circuses are in full swing. Unfortunately, animals who are made to perform in circuses lead a life of loneliness and despair. Instead of going to circuses with performing animals such as Ringling Brothers or Circus Vargas, take your family to a circus where only humans perform, such as:

Cirque du Soleil (Circus of the Sun)
1217 Notre-Dame St. E.
Montreal, Quebec H2L 2R3
1-800-678-2119
www.cirquedusoleil.com

And, remember the carnival is no fun for the goldfish won as

prizes. Explain to the carnie why you'd rather have a stuffed animal as a prize rather than a stressed and lonely goldfish.

Light a candle On the third Saturday in August, light a candle or hold a candlelight vigil in observance of National Homeless Animals' Day. Share the experience with friends by holding a vigil at a park or at the beach. Make a candle holder by taking a paper cup and making a hole in the bottom for the candle. The candle wax will drip into the cup; not on your hand. To receive a free "Vigil Packet," which includes information on how individuals and groups can organize their own vigils, contact:

International Society for Animal Rights

965 Griffin Pond Rd.

Clarks Summit, PA 18411

1-800-543-ISAR

www.i-s-a-r.com

Record a message on your answering machine Tell your friends and family how much you care about farm animals. As part of your regular outgoing telephone message, include a short quotation or statement about animals. For example: "This is Mary. Please leave me a message. And remember, farm animals need compassion too. Have a meat-free dinner tonight."

Join animal-friendly clubs Clubs such as the National 4-H Club advocate youth development but do not take into consideration the animals who are discarded at the end of the "project." Instead of participating in a 4-H project, encourage your kids to join an organization such as Youth Corp for Animals. Their Web site (www.youthforanimals.org) is designed to help young people find volunteer opportunities with animal organizations in their own communities and beyond.

Or learn more about Youth for Environmental Sanity (YES!) and its vegan camps around the world. YES! summer camps inform, inspire, and empower youth ages fifteen to twenty-five to take positive action for healthy people and a healthy planet. Visit their Web site at: www.yesworld.org or call (877) 293-7226.

Place a call Learn more about dissection and your right to choose by placing a call to the *Dissection Hotline* which is

sponsored by the National Anti-Vivisection Society (NAVS). Call 1-800-922-FROG (3764). NAVS also operates a companion program, the NAVS Dissection Alternatives Loan Program which loans out hundreds of alternatives (CDs and models) to students and teachers nationwide.

Wear a green ribbon In observance of Cut Out Dissection Month during October, show your support of dissection alternatives by wearing a green ribbon to school (like the AIDS red ribbons). The green ribbon symbolizes the millions of frogs and other animals who end up on the dissection table every school year. Fellow students will be interested in what the ribbon signifies, and this will be an opportunity for you to educate them about the various alternatives to dissection and their right to choose.

Display a bumper sticker on your car to show you oppose dissection Parents can support their kids with their decision not to dissect by putting a bumper sticker on their car. Actress Jamie Lee Curtis boasts a bumper sticker reading "Proud parent of a child who won't dissect." Her daughter Annie is a student and very active in the animal-rights field. You can order a free bumper sticker from People for the Ethical Treatment of Animals (PETA) by sending an E-mail message with your name and address to: education@peta-online.org.

Take a walk Horse-drawn carriages can be cruel to animals. Horses are forced to pull heavy loads of people during the blistering hot summers and the freezing winters in many parts of the country. Take a walk instead of a carriage ride. Put your hoof down and just say no to carriage rides.

Purchase an adoption gift certificate Looking for just the right gift for a friend or relative? An animal adoption gift certificate may be perfect. Giving a live animal as a present for any holiday is never a good idea. So many of the animals end up in overcrowded shelters when the novelty of having a new puppy or kitten wears off, and families realize they were not prepared to give the love and attention the animal requires.

If you're certain your friend or relative would like a companion animal, purchase an adoption gift certificate from your local

animal shelter. The recipient of the certificate may then go after the rush of the holidays to select just the right animal for his/her lifestyle and budget.

Give a gift basket Gift baskets filled with cruelty-free products make wonderful gifts for your friends and family. For a complete listing of companies that do not test their products on animals, visit: www.allforanimals.com/cruelfree1.htm.

Purchase merchandise from your favorite animal protection organization Purchase gifts such as t-shirts, coffee mugs, calendars, and books from organizations working on behalf of animals. Most organizations have Web sites for easy ordering, or you can call and request their product catalog.

Make a cruelty-free donation We are often asked to make a donation to assist a charitable organization with its various programs and services. But did you know that many organizations, such as the March of Dimes and the American Red Cross, fund animal experiments with your contribution dollars? Or that the Multiple Sclerosis Association of America and the American Kidney Fund DO NOT fund animal research?

Make an informed decision about charities that do and do not fund animal experiments by ordering a free "Guide to Cruelty-free Giving" brochure produced by Physician's Committee for Responsible Medicine (PCRM). PCRM is a non-profit organization which, among its other services, works to educate the public about the various health charities that do and do not fund animal experiments.

For more information on cruelty-free charities, contact:
Physicians Committee for Responsible Medicine
5100 Wisconsin Ave., Suite 404
Washington, DC 20016
(202) 686-2210
www.pcrm.org
www.charitiesinfo.org

13. Making a Little More Effort to Help Animals

"Not to hurt our humble brethren is our first duty to them, but to stop there is not enough."

—St. Francis of Assisi (1181–1226),
Patron saint of the animals

An Unlikely Hero
by Jo Marchant

We all have heroes of one kind or another, and it just so happens that one of mine was brown, furry, lop-eared and had four legs. Her name was Peach. When I say she saved my life, I really mean it, though it was not that she intervened in any physical sense to save me from danger. She came into my life at a time when I really needed the unconditional love she offered so freely. Although Peach has passed away, she continues to live on every day in the wonderful memories I have of her and in the dozens of other rabbit companions who followed her lead into my life.

I was thirty-eight and Peach was just five weeks old when I stumbled upon her one hot August day. Like many of us, I adopted my first rabbit, unable to resist those deep brown eyes and long floppy ears. Little did I know my adoption that day would introduce me to the world of rabbits and the perils of breeding, animal testing, and abandonment, and a role that I would eventually play in enabling these small creatures to have a good quality of life.

Peach had a very great task. It fell to her to teach me about things I had, so far, found difficult to learn: like the power of unconditional love; how to be comfortable in my own skin and care

deeply about another being; and how to really laugh. She would do this by simply being her own rabbit self each day, unselfconscious, playful, and living according to the cycles of her own body and spirit. Life was simple. When she was hungry she ate, when she was tired she slept. There was time for her work of digging in corners, and she always made time for playing, with or without me.

Peach Enters My Well-Ordered Life

We lived in a very small, one bedroom, no-pets-allowed apartment. Here, day after day, Peach would both delight me and wreak havoc in my well-ordered life. I knew nothing about rabbits or their rascally little habits of chewing everything forbidden, like books and baseboards, chairs and cords, belts and shoes. I knew nothing of their capacity to race through three rooms and back, then land on the sofa next to me in under five seconds. Nor did I know rabbits could get into the smallest of spaces, like under my fridge, or make the loudest of noises with their small back feet when the rest of the world was still sleeping. It's good I didn't know, because I might never have brought Peach to live with me.

On the other hand, if I had known that one small being could bring such joy and pleasure into my life, I'd have found her a lot sooner than I did. The important thing, though, is that I did find her. My great friend, Peach, who would jump into the shower with me at 5:30 in the morning, before she understood what happened behind that curtain, and lay at the kitchen door while I prepared supper for the two of us. My faithful companion, who would sit for hours beside me or run across my scrabble board in the middle of a game. This mischievous rabbit, who severed my telephone cord one Christmas day as I talked long distance to my mother, kept me going and going.

I needed to lighten up. I had gone through some very difficult periods in my life and I still carried the scars. Peach didn't care about this at all. She was young and happy and full of life and she wanted me to enjoy her and get lost in her world. She wanted me to see things from her perspective. Everything was brand new. She had a home, lots of good food, and someone who thought she was

the most amazing creature on earth. Wasn't life wonderful? It was impossible not to laugh at her antics and aerial displays. I missed her when I was out and enjoyed her company when I was at home. Whether we watched television or snuggled in bed together, or she got into all my "good stuff," or ate my favorite nightgown, it didn't matter. After a few weeks, I had fallen in love with her. There was no turning back. Now that Peach had found her way into my heart, I was ready to learn.

Lessons Peach Taught Me

Peach taught me the really important lessons I needed to know by just being. Oftentimes, when we are taught things as children, the words we hear are different than the actions we see. The message gets muddled and confusing. As I watched Peach, I learned it was okay to be happy or frustrated or angry. She was very clear about how she felt and had no difficulty expressing it to me through a thump, a nip, or a hop into the air. I thought it was so wonderful that she could live so fully in her own rabbit skin without apologies or comparisons or wishing she was anything else. Over time, and without knowing it, I began to imitate her. In doing so, I discovered new aspects of myself. Once I discovered it was safe to just be myself with her, it was something I wanted to do more and more.

When Peach passed away, I was heartbroken. She seemed to be slowing down, and I had a feeling the time was coming when I needed to say goodbye to her. Our last few hours together are something I will never forget. I talked to her, certain that she heard and understood every word. I thanked her for coming into my life and letting me love her and for all that she had taught me. I assured her that I would never forget her.

I never will.

For a long time, I was uncomfortable with the fact that the first earth creature I felt completely safe and comfortable with was a rabbit and not another human being. Does it really matter? I don't think so. Animals teach us far more than we give them credit for. We all have our stories and are shaped by a myriad of positive and negative life experiences. The important thing is that we are

open to receiving love, no matter what form it comes in. Some people go through life without ever experiencing love. That is the real tragedy. So if it comes late in life, or if it comes through another human being, or through a cherished pet, it's a gift to be acknowledged and celebrated.

Peach's legacy to me was that simple. There's not a day that goes by when I am not reminded of it. She's buried in our garden under a colorful burst of perennials in the spring and summer and a warm mound of snow in the winter.

There's a lot of laughter and love in our home thanks to her. Peach was an unlikely hero with an uncomplicated message.

Jo Marchant lives in Ottawa, Ontario, Canada and spends much of her time caring for rescued rabbits and doing education on their behalf. She publishes a newsletter for pet rabbit enthusiasts called "The Bunny Thymes," now in its sixth year. Jo also enjoys photography, writing, gardening, her dog Chinook, and cat Mattie.

A Little More

In chapter twelve, you saw just how easy it is to incorporate cruelty-free tips into your daily life. Now, consider taking a little more time and effort on behalf of the animals. The tips in this chapter result in rewards that are definitely worth your while.

Keep your cats indoors Free roaming cats are responsible for the destruction of millions of birds every year. Sadly, cats who are allowed to roam outdoors have a life expectancy of only two to five years, while indoor cats can live seventeen years or more. By keeping your cat indoors, the birds and cats remain safe. Dr. Greg McDonald, a veterinarian in Santa Barbara, California estimates that, in his ten years as an emergency hospital veterinarian, 90 percent of the cats he treated had been allowed outside and would not have been in need of emergency services, if they had been indoor cats. Common injuries were trauma from cars, dogs, other cats, and contagious diseases from exposure to other outdoor cats. On average, a visit to the animal emergency hospital costs $300 to $400, which doesn't include follow-up visits or medication.

For more information on how cats and birds can co-exist peacefully, contact:

American Bird Conservancy

Cats Indoors! The Campaign for Safer Birds and Cats

1250 24th Street, NW, Suite 400

Washington, DC 20037

(202) 778-9666

www.abcbirds.org

Feed the birds Birds are especially susceptible to low food supplies in the winter. You can help them during the cold winter months by placing a bird feeder in your yard. Be sure it's suspended several feet off the ground, so the birds remain safe from other animals. The birds will appreciate your gesture, and you'll enjoy watching them. Don't feed the birds all year long, however, as they'll become dependent on humans and will lose their natural instinct to gather food. You can also assist the birds by planting shrubs and bushes that produce berries and seeds and by adding a birdbath to your garden. According to the National Bird Feeding Society, keeping clean seed, feeders, and water is very important.

Post "No Hunting" signs If you live in a rural area, post "No Hunting" signs on your property during hunting season to keep the animals safe from human predators.

Learn more about wildlife To learn more about co-existing with wildlife, read the book, *Wild Neighbors: The Humane Approach to Living With Wildlife*, by John Hadidian, Guy R. Hodge, and John W. Grandy (Editors). *Wild Neighbors* is available through your local bookstore or on the Amazon.com Web site (www.amazon.com).

Spay or neuter your companion animals Spay (female) or neuter (male) your own companion animal. Encourage friends, family, and neighbors to do the same. Altering a companion animal eases the overpopulation problem and helps prevent certain diseases in animals such as prostate cancer and diseases of the ovaries.

Get involved with Spay Day USA The Doris Day Animal

Foundation hosts Spay Day USA, an annual, month-long event which seeks to increase awareness of the pet overpopulation problem. In 1999, Spay Day USA celebrated its fifth anniversary with over 250,000 animals spayed or neutered in the previous four years. For more information on how you can get involved with Spay Day USA, contact:

Spay Day USA
Doris Day Animal Foundation
227 Massachusetts Avenue, NE, Suite 100
Washington, DC 20002
(202) 546-1761
www.ddal.org

Rent an animal birthing video Parents are often eager to show their children the miracle of birth by allowing their companion animal to give birth to a litter of puppies or kittens. This only perpetuates the problem of pet overpopulation. Instead, show the miracle of birth by purchasing or renting a video tape of an animal giving birth. When you're done with the video, donate it to your local library, so other people may become educated.

Read a book about animal theft You can learn more about the pet theft problem by reading *Stolen for Profit* by award-winning journalist Judith Reitman. Ms. Reitman takes an in-depth look at the animal theft business and shows how profiteers stalk family pets and sell them to unscrupulous labs at universities, drug manufacturers, and cosmetic companies.

Avoid placing "free to good home" ads If you absolutely must find a new home for your companion animal, never run a "free to good home" ad in the newspaper unless you are prepared to do a home visit and thoroughly interview the prospective adopter. Ask for references, including a driver's license number, telephone numbers, and a place of business. Never release your animal before visiting the prospective adopter's home. Sadly, "bunchers" often respond to these ads and then sell the animals to research laboratories and illegal dog fighting rings.

Try a meat-free meal There are several foods you can begin to introduce into your diet such as veggie burgers (available at most

restaurants and in the frozen section of your supermarket), vegetable soups, nuts, grains, pastas, potatoes, and soy products (such as tofu). Start with one meat-free meal a week if you wish. An ideal day to try a meat-free meal is March 20, the Great American Meatout Day.

Make the meal fun Invite your friends over for a vegetarian meal and serve it on your best china. Light candles and put on enjoyable music. Celebrate the event!

Read food product labels Read labels in the grocery store. Some vegetarian items may be made with a meat broth. You may choose among any number of meat alternatives such as Garden Burgers®, Smart Dogs®, and Phoney Baloney®.

Subscribe to a magazine From snacks to full course meals, *Vegetarian Times* offers healthier new recipes for classic food dishes. In every issue, you'll find seasonal menus, health news, advisories, reports, and research findings, as well as guidance on diet, exercise, and nutrition. For subscription information, contact:

Vegetarian Times
P.O. Box 420235
Palm Coast, FL 32142-0235
1-800-829-3340
www.vegetariantimes.com

Write checks with a message What better way to pay your bills than with "Message Checks?" Message!Products is a check printer working with animal protection and other non-profit organizations to provide personal checks, hemp covers, address labels, and other licensed merchandise. Royalties from every order go directly to the organization you choose. For more information, contact:

Message!Products
P.O. Box 64800
St. Paul, MN 55164-0800
1-800-243-2565
www.messageproducts.com

Purchase pet health insurance According to the American Veterinary Medical Association, pet guardians spent approximately $11.1 billion on pet health care in 1996. Purchasing pet health insurance for all your companion animals will give you peace of mind that your pets will receive all the care they need in case of an injury or illness. Talk with your veterinarian for more information on pet health insurance providers.

Be prepared for a natural disaster What would you do if you were faced with a natural disaster like a fire, flood, or earthquake? Have you made preparations for your animals?

The United Animal Nations offers these tips:

- Always keep a breakaway collar and tag on those animals who should normally wear collars (even for cats who never go outside).
- Identify several possible locations where you can take your animals should you have to evacuate.
- Start a buddy system with someone in your neighborhood, so that they will check on your animals during a disaster in case you aren't home.
- In addition to your regular supply of animal food, have at least a week's supply of food and water on hand to be used during a disaster.
- Take several pictures of all your animals and keep these pictures with your important insurance papers.
- Before a disaster strikes, talk to your veterinarian to see if he or she has a disaster plan.
- If an animal is on long-term medication, always keep a backup supply on hand, since a veterinary office may not be open for some time following a disaster.
- Have assembled and ready to go, a cat carrier to evacuate each cat in your household.
- Have a harness and leash for all the dogs in your household.
- Be sure to comfort your animals during a disaster.
- Know where the animal shelters or animal rescue organizations are in your area.

For more information on preparing for a natural disaster, contact:

United Animal Nations
5892A South Land Park Drive
P.O. Box 188890
Sacramento, CA 95818
(916) 429-2457
www.uan.org

You may also purchase the book *Out of Harm's Way* by Terri Crisp, the Director of United Animal Nations' Emergency Animal Rescue Service program. The last fifty pages of the book have life-saving tips for domesticated animals, horses, and livestock. Anyone who has animals should have this valuable resource guide.

Write a letter Encourage your senator or congressperson to support an upcoming animal bill by writing a letter or sending them an E-mail message. The Doris Day Animal League Web site has a quick and easy way for you to compose and print letters to your elected officials. Visit their Web site at www.ddal.org/leghomepage.html. Or send a postcard with your views on a certain topic to your senator and representatives. Address the postcard to:

The Honorable _____ The Honorable _____
United States Senate U.S. House of Representatives
Washington, DC 20510 Washington, DC 20515

Dear Senator, Dear Representative,

Adopt an adult or older pet Kittens and puppies can be irresistible, but adult cats and dogs make wonderful companions too. The advantages of adopting an older animal companion are that he is already house-broken, he is calmer, and his personality is apparent. Be sure to adopt a cat or dog from an animal shelter, humane society, or other type of rescue organization, not a pet store where many of the animals were obtained from puppy mills or backyard breeders.

Prevent behavior problems Many cats are relinquished to

animal shelters because of behavior problems, such as scratching furniture and carpets. Unfortunately, many people think declawing a cat is the solution to the scratching problem. Declawing is painful and often psychologically damaging. It is even illegal in England to declaw a cat. The traditional declaw surgery removes not only the claw, but the first section of each toe, which includes bone and ligament. There are now less invasive surgeries done by a laser. Ask your veterinarian for more information.

Instead of declawing, try these tips:

• Give your cat a manicure—if possible, start cutting your cat's claws when he is a kitten so he becomes used to the procedure. Press on his foot to extend the claw, then cut the claw with a pair of sharp clippers made especially for cats. Never cut close to the pink veins or "quick."

• Purchase one or more scratching posts and place them in various locations in your home. Spray with catnip to encourage your cats to use them.

Enroll your dog in an obedience class Dogs who were not taught basic obedience commands are six times more likely than trained dogs to be relinquished to shelters. Free or low-cost training is often available through your local animal shelter or the city in which you live.

Travel with your pets by car instead of by air Dogs love to be with you and especially love to ride in the car. But airline travel can be dangerous for any animal, especially during the summer, because animals are often forced to fly in the cargo area of the plane, which is not pressurized. According to a report by the San Francisco SPCA, more than 5,000 animals die or are injured during air travel every year.

If you must take your pet on an airplane, follow these tips:

• Never travel if the outside temperature is above 85 degrees.
• Travel early in the morning.
• Book only a non-stop flight.
• Be sure your animal has adequate food and water. (For longer flights, put ice cubes in the water tray. They will melt over time, ensuring a constant water supply.)

Some airlines allow small animals (a cat or small dog) to travel in the cabin with you, if they fit under your seat. Check with the airline for their requirements on a pet's size and the type of carrier they allow.

Microchip or tattoo your companion animals Be sure your companion animal is microchipped or tattooed so, in the event he does become lost, he can readily be returned to you. Have your pet tattooed on the rear inner leg, not the ear. Thieves or unscrupulous research labs have been known to cut off the ear to eliminate the tattoo. If done correctly, the tattoo is painless, takes only two or three minutes, and is permanent.

For more information on tattooing, contact:
National Dog Registry
1-800-NDR-DOGS
www.natldogregistry.com

Electronic microchips are approximately the size of a long grain of rice and carry a coded identification number. The chip is implanted under the pet's skin and can be read using a specialized scanner. It's a good idea to put an announcement on your pet's I.D. tag that says he has been microchipped. The microchipping procedure is similar to giving an injection and can be quickly and easily performed by a veterinarian. Contact your veterinarian for referrals of microchipping services in your area.

Help a hurt animal We've all seen a hurt or abandoned animal on the side of the road. What should you do?

Be prepared.

Carry a blanket or towel and pet carrier (or cardboard box with airholes), a leash, and heavy gloves in the trunk of your car. *Approach any stray or injured animal carefully.* Gently restrain the animal and take him to the nearest veterinarian or pet emergency hospital for treatment. If you're unable to move the animal, call the police or an animal control officer. Keep phone numbers handy in the glove compartment of your car or in your wallet.

Help a lost animal If you find a stray dog running loose (but not injured), bring him to your local humane society or animal shelter, or if you can, bring him home with you. Newspapers often

have free "found dog/cat" listings in the classified section of the paper. If you find a dog or cat, run an ad with a *vague* description of the animal; make the person describe their lost animal *in detail* or show you a picture of the pet before relinquishing the animal to them.

If you cannot bring the animal home with you, contact your local humane society or animal shelter. They may have night deposit boxes where you can safely place the animal until the shelter opens the next morning. However, don't leave an animal if the temperature is below sixty degrees. Be sure to fill out the card provided with any pertinent information such as where you found the animal.

Learn more about homeless animals Read a book such as *Lost and Found: Dogs, Cats, and Everyday Heroes at a Country Animal Shelter*, by Elizabeth Hess. This book will encourage you to rethink your relationships with domestic animals. Hess first visited a New York animal shelter to adopt a dog for her daughter. What she found inside the shelter inspired her to write *Lost and Found*. You'll be introduced to innumerable animals and humans who will inspire, educate, and break your heart. Visit your local bookstore or order online at www.amazon.com.

Educate yourself about factory farming Downed animals (animals too sick to stand), rampant antibiotic use, veal production, and environmental pollution are all part of the modern factory farm.

The Humane Farming Association produces STOP FACTORY FARMING mailing stickers which you can place on all your outgoing mail; a great way to get the message out. Twenty sheets of six stickers is $1.00. Order through The Humane Farming Association's Web site.

For more information about factory farming, contact:

The Humane Farming Association

PO Box 3577

San Rafael, CA 94912

(415) 771-CALF

www.hfa.org

Visit a farm sanctuary Have you ever given a pig a belly rub? Talked to a turkey? Or petted a cow? The critters at Farm Sanctuary in upstate New York and California love visitors as much as you'll love their unique shelters. If you live in either New York or California or are planning a vacation to either state, consider stopping at Farm Sanctuary in the Finger Lakes Region of New York and in Orland, California, 100 miles north of Sacramento. You'll wake up to crowing roosters, enjoy a fun and educational farm tour, and dine on vegetarian meals.

For more information, contact:

Farm Sanctuary

P.O. Box 150

Watkins Glen, NY 14891

(607) 583-2225

www.farmsanctuary.org

or

Farm Sanctuary

P.O. Box 1065

Orland, CA 95963

(530) 865-4617

www.farmsanctuary.org

Ask your instructor for a non-animal assignment More and more, science labs at many schools now emphasize computers rather than animal cadavers. Computer software programs such as *Digital Frog 2* create an interactive learning experience for students without harming animals. Set up a time to meet with your instructor and in a calm and polite voice, tell him or her that you do not wish to participate in a classroom dissection. Ask for an alternative, non-animal assignment. The Humane Society of the United States has established the Humane Education Loan Program (HELP) to provide students and educators with up-to-date alternatives to classroom animal dissection.

For more information on HELP, contact:

The Humane Society of the United States

www.hsus.org/programs/research/animals_education.html

(301) 258-3024

For more information on *Digital Frog 2*, contact:

Digital Frog International, Inc.

Trillium Place

RR #2, 7377 Calfass Road

Puslinch, Ontario N0B 2J0 CANADA

1-800-621-FROG

www.digitalfrog.com

Order a free Cut Out Dissection pack Available from the People for the Ethical Treatment of Animals (PETA), the Cut Out Dissection pack includes samples of letters to professors, dissection choice policies, letters to the editor, and much more. For ordering information, contact:

People for the Ethical Treatment of Animals

501 Front Street

Norfolk, VA 23510

(757) 622-7382

www.peta-online.org

CollegeAction@peta-online.org

Adopt an animal from an animal shelter or rescue group There are many wonderful animals awaiting adoption at animal shelters across the country. Adopt an animal companion from your local shelter or rescue group instead of a pet store. Most dogs for sale in pet stores are obtained from puppy mills which are mass breeding facilities located primarily in the Midwest of the United States. Animals in puppy mills live in dirty, cramped conditions where they may come in contact with various diseases; these animals may also have behavioral problems.

For a listing of animal shelters in your area, look in the yellow pages of your phone book under headings such as "animal shelter," "humane society," or "animal control" or look at directories on the Internet. (A list of online directories can be found in the Resources section at the back of this book.) If you have your heart set on a purebred dog or cat, first check with your local shelter. They may have a "breed rescue" list with purebred animals for adoption. Remember, 25 percent of all dogs relinquished to a shelter are purebreds. If you cannot find just the right animal

companion, ask your veterinarian for a *reputable* breeder in your area.

Ask an animal shelter for its "wish list" Every animal shelter has different needs and they may have created a "wish list." Most have a need for items such as newspapers (for lining the bottoms of cat cages), old towels, cat socializers, foster parents for kittens, and dog walkers. They may also have a need for office workers, newsletter editors, and greeters. These volunteers may assist with the placement of animals, educating the public, fundraising events, and administrative support. Call your local animal shelter and ask them for a list of items you can donate or services you can provide.

14. Helping Animals as a Way of Life

*"Nothing living should ever be treated with contempt.
Whatever it is that lives—a man, a tree, or a bird—should
be touched gently, because the time is short. Civilization is
another word for respect for life."*

—*Elizabeth Goudge (1900–1984),* The Joy of the Snow

Welcome Home
by Dick Michener

Even on the Gulf Coast of Florida, we experience seasonal changes. One Thanksgiving afternoon, after we'd watched football and just before we served dinner, my dad Larry and my dog Misty were napping together as usual. Larry was stretched out on a long, comfortable couch beneath a picture window, and Misty was stretched out on the soft carpet beside him.

On a day when the temperature outside remained in the forties, and a north wind was escalating, an ironically bright sun made the Florida room deceptively warm, an ideal place for Larry and Misty to warm their venerable bones together. Their bodies seemed to be as thin and impermanent as ancient parchment. They seemed to be almost translucent. Rays of sunshine seemed to stream through their bodies and scatter across the fabric of the couch and the carpet. Surveying the scene, my wife said, "They look like the last leaves up north. We won't have them with us much longer."

I nodded. "We may have one more holiday season with them."

Larry and Misty were similar in many ways and so they stayed close together whenever my dad would visit us. Even though

Larry and Misty both had been traumatized in their youth, both were sensitive and kind. They were strong, athletic, and led clean and active lives. Nonetheless, they were ravaged by diabetes.

Larry and Misty maintained their level of health and fitness throughout the holidays. Shortly into the new year, however, they experienced shocking terminal drops. What should and could be done for them?

With my dad, the decision had not been easy, but it was simple. Dad had led a long and rewarding life. He did not want to become imprisoned in a declining and lonely state, kept alive by life-support. With respect and resolve, I made sure that his wishes were honored. With love and appreciation, I let him go. With gratitude and joy, he departed. We both knew we would meet again.

With Misty, however, the decision was not as easy. She seemed so strong and active to people who did not know her well. Misty's veterinarian advised us that the problems of progressive diabetes outweighed the benefits of continuing her life. On Friday, we agreed that Misty should enjoy one final weekend at home. Misty seemed to have a glorious final three days at home. The cool and bright weather was perfect for her.

Misty Goes Home

Early Monday morning, as we sipped our coffee on the back deck, Misty gingerly went down the steps, made a slow inspection of our entire back yard, paused under each giant oak, and then carefully made her way back up the steps to sit at our feet. She looked quizzically up at us. We reached down and through tight smiles stroked her and told her what a wonderful dog she was and what an indispensable member of our family she had become. She licked our hands and then looked hopefully up at us. Fearing I soon would lose the will to proceed, I quickly put her on leash, opened the back door, and led her out to the car.

At the clinic, Misty rushed toward her veterinarian who bent over to greet her. "Misty, you're such a fine dog. Soon, you'll be in a happy place, free from pain and able to keep watch over your

entire family until it's time for them to join you," she said. Then the vet motioned Misty and me to a side room containing a single chair. As I sat down, Misty rubbed against my leg and lay down at my feet, resting her head atop my shoes. As her veterinarian gently put her to sleep, Misty raised her head and looked up at me. With a sigh of contentment, she lay her head back down and closed her eyes. Her head became so soft and pliable that it seemed to fold itself down around my shoes. Ever so quietly, Misty passed away.

"Misty's already home," her veterinarian said.

Many seasons have come and gone since Misty and my dad passed away. Recently, I had a wonderful dream about them. I was enjoying a soft spring day up north in a pristine and verdant park. Ascending through a pleasant mist from the bottom of the steepest of a series of hills, I looked up into the sky. Unexpectedly through the mist, I saw Misty and my dad. Blinking, I saw them again and, as they began to move across the sky, it seemed that I was watching a video of my future afterlife played upon a boundless screen. In that video I was again in a park. This time the park was beautiful beyond belief, rising from a valley on a spring day, refreshing beyond imagination. Looking up at that video, I saw an ideal log cabin set atop a pinnacle. Three stories tall, that cabin was bathed in sunshine and replete with decks and porches, all of them filled with every person I had ever loved.

All of them were waving and motioning me to hurry up the hill, so they could begin an unending housewarming party as I entered my eternal residence. They shouted glad tidings, but their words dissolved in the mist before they reached me in the valley.

Suddenly, I heard divine sounds. A cacophony of joyful meows and barks made by all the creatures I had ever loved, resonating over and over as they emerged from behind the cabin and rushed down the hill toward me.

Running halfway up the hill, I knelt down, closed my eyes, and extended my arms to embrace them. Opening my eyes again, I saw Misty racing at the head of the pack with my dad beside her.

Just before reaching me, they both made eye contact. With their eyes, they said in unison, "Welcome home."

Dick Michener is a writer and an Internet entrepreneur. He lives with his wife Sandy and two wonderful Shar-Pei's, Genghis and Yellow, in St. Petersburg, Florida. "Welcome Home" reminds us of one of the hardest decisions we must make—knowing when it's time to let a beloved animal go.

A Change in Lifestyle

By now, you have likely incorporated many of the cruelty-free tips suggested in this book into your own life. The tips suggested in this chapter will allow you to explore ways in which you may change your lifestyle to benefit you, your family, and the animals.

Put your companion animal in your will Of course, we all don't want to think about it, but what would happen to your pet should you die or become incapacitated? According to the American Society for the Prevention of Cruelty to Animals (ASPCA), only 18 percent of people make provisions for their companion animals in their wills.

First, locate a friend or relative who is willing to take your pets and give them a good home upon your death or incapacity. *Be sure to consult an attorney to ensure your wishes for your companion animal are carried out.* Ask your attorney to draft a will or amendment to your existing will, leaving your pet to the friend or relative you have chosen. You may also wish to set aside a sum of money for the continued care of your pet. Keep in mind, some states do not allow you to leave money directly to a pet; you must leave the money to your friend or relative, in trust, for the care of your pet.

A sample statement in your will may read:

My Executor shall give my [cat] to one or more of the following persons who agree to care for my [cat] and to treat him as a companion animal: [Mary Smith, my mother], residing at [address] or [John Doe], residing at [address].
My Executor shall have the discretion to select one or

more of the persons named above to receive my [cat]. If none of such persons are willing or able to take my [cat], my Executor shall have the discretion to give my [cat] to another person or persons who agree to care for such [cat] and to treat him as a companion animal. My Executor shall give [$_____] to the person selected by my Executor and who accepts my [cat].

Also, if you live alone, type up an "Emergency Care of Companion Animals" card and place it in a prominent place in your wallet. It may read something like this:

In the event I am unable to return home to feed my [cat], such as my hospitalization or death, please call [Mary Smith] at [address and phone] or [John Doe] at [address and phone], to arrange for the feeding of my [cat] located in my home at [address]. My landlord [name, address and phone], my Executor [name, address and phone], and my neighbor [name, address and phone] have copies of this document.

For more information on providing for your pet in your will, read the online brochure entitled "Providing for Your Pets in the Event of Your Death or Hospitalization," produced by The Association of the Bar of the City of New York (ABCNY). Their Web site address is: www.abcny.org.

Purchase cruelty-free toys for your companion animals Your pets will love the cruelty-free toys and treats you purchase for them. Try a product like "Booda Velvets" which are flavored chews made of natural cornstarch material and are free of animal by-products and preservatives. Avoid buying toys made from rawhide; it's a slaughterhouse by-product. And avoid products by such companies as Hartz; their toys contain real fur (they even print this on the back of their packaging!).

Purchase cruelty-free products It's becoming easier to find household products, personal care products, and cosmetics that are

not tested on animals. Look for products which display the new international "rabbit" logo (shown in chapter 2).

Here's a bonus tip: If you have an allergic reaction to a certain cosmetic or lipstick, it is often because of the "carmine" in the product. Carmine is a red pigment chemically extracted from scaly insects. Uses for carmine include dyes for cloth, food coloring, and cosmetics. Every year, seven billion beetles are used in the production of carmine.

Purchase cruelty-free clothing and bedding If you have a passion for fashion, purchase clothing and shoes that are not made from animals. It's an easy decision not to wear fur, but how about leather shoes and belts, silk scarves, and wool coats? Eighty percent of wool comes from sheep in Australia where tail-docking and castration without anesthesia is commonplace. Down feathers are often plucked from live geese, and silkworms are used to make silk garments. Purchase synthetic-filled comforters and pillows instead of products made with real down. It's now becoming easier to purchase leather-free clothing and shoes. For instance, Calvin Klein® recently introduced belts made from molded plastic. Payless® shoe stores have a wide selection of plastic, canvas, and fabric shoes at inexpensive prices. And, Nike® has a whole line of non-leather sport shoes.

Look for clothing and other products made out of cotton, ramie, rubber, linen, canvas, synthetics, and hemp. Hemp, a plant which was the number-one crop in America at the turn of the 20th century, is making a comeback. Clothing, shoes, soaps, food, and tree-free paper can be made from the hemp plant. Woody Harrelson ("Woody" on the popular TV show *Cheers*) is a prominent supporter of hemp and can be seen sporting a stylish pair of hemp shoes in various magazine ads.

For more information on hemp, contact:
Hemp Industries Association
PO Box 1080
Occidental, CA 95465
(707) 874-3648
www.thehia.org

Invest in animal-friendly companies During the 1990s, cruelty-free investing entered the mainstream. You can make a difference for animals by investing in companies that don't employ animal testing or use animals for entertainment. Consider investing in a cruelty-free mutual fund such as the IPS Millennium Fund. The Business Analysis Group of Reston, Virginia has a Web site with several fact sheets on cruelty-free investing such as "picking cruelty-free stocks" and "cruelty-free money market funds for small investors." The site also has links to several other cruelty-free advisory sites. The group's motto is, "Animals are not ours to profit from." *As with any stock purchase, consult with a financial advisor before making a purchase.*

For more information on cruelty-free investing, contact:
Business Analysis Group, Inc.
P.O. Box 3534
Reston, VA 20190-1534
members.aol.com/cfinews

Buy an animal-friendly car Car companies such as Saab now have vehicles available with an entire line of accessories especially for pets, including restraint devices. Saab consulted with The Humane Society of the United States in developing these products. Ask a car dealer if their vehicles include safety devices for pets.

Use cloth bags for your groceries Plastic bags are a detriment to the environment and the animal kingdom. Instead of using plastic bags when you go grocery shopping, you can bring your own cloth (washable) tote bags. Many animal protection organizations and grocery stores offer tote bags for sale.

Feed a feral cat colony Feral cats are semi-wild cats who form colonies and live near food sources, such as a dumpster behind a restaurant. Most of these cats were once companion animals who became lost or were purposely discarded. There are an estimated 60 to 100 million feral cats in the United States today. Innovative programs are now in place around the country to curb the feral cat overpopulation problem. Called "Trap-Neuter-Return" (TNR), these programs help control the colony population and help the cats to lead longer, healthier lives. In many parts of the country

where there are no such programs in place, cats are routinely trapped and euthanized.

TNR is a cost-effective program which reduces euthanasia by as much as 40 percent while saving millions of taxpayer dollars and precious feline lives.

To learn more about Trap-Neuter-Return, order the video *Trap, Neuter, and Return: A Humane Approach to Feral Cat Control* produced by Alley Cat Allies. The video is a comprehensive training video which gives complete, easy-to-follow instructions, advice, and encouragement to anyone who wishes to help feral cats.

To order a video or for more information on feral cats, contact:
Alley Cat Allies
1801 Belmont Road, NW, Suite 201
Washington, DC 20009
(202) 667-3630
www.alleycat.org

Knit "snuggles" for shelter animals Do you love to crochet, knit, quilt, or sew? If so, you can help shelter animals by making "snuggles," a knitted security blanket animals can lay on to feel warmth and security. Dogs and cats awaiting homes at animal shelters are often kept in cages with stainless steel braces or cement floors. A snuggle of their own allows them to have a little reprieve from the cold. Recommended sizes are: twelve inches by twelve inches for cats and small animals, twenty-four by twenty-four for medium dogs and other animals, and thirty-six by thirty-six for large dogs and other animals. Snuggles need not be exactly this size and they don't need to be perfect either; they just need to be knitted with love! Once an animal is adopted, they take their snuggle with them to help in the transition to their new home.

For more information about snuggles and to receive free patterns, contact:
Hugs for Homeless Animals
www.h4ha.org

Volunteer your time Volunteer your time or make a monetary contribution to your local animal shelter. Shelter staff are often so

busy caring for a dog's or cat's most basic needs like food and water, there is little time left for anything else. That hour or two you spend at the shelter can be spent playing with or grooming the cats or walking and generally socializing the dogs. The time you devote to the animals will help increase their chances of being adopted into a loving, permanent home.

Become a vegetarian Make a commitment now to become a vegetarian or a vegan. (Reminder: a vegetarian is someone who doesn't eat meat, poultry, or fish and a vegan is someone who abstains from all meat, poultry, and fish as well as eggs, cheese, and milk.) A vegan also avoids all other animal by-products such as lard, gelatin (vitamins are often made with gelatin coating), honey, whey, and rennet (the lining of a calf's stomach which is found in many cheeses).

III.
Learning More about
Being Kind to
Animals

15. Resources for Living Cruelty-free

"The greatness of a nation and its moral progress can be judged by the way its animals are treated."

—*Mohandas K. Gandhi (1869–1948)*

This chapter gives you the opportunity to learn more about the various topics discussed in this book. It features a small selection of Web sites, books, newspapers, and magazines devoted to animal protection.

You will find listings for:

Online resources:

> General Web sites of U.S. animal protection
> > organizations
>
> National and worldwide directories
>
> Lost and found pets
>
> Letter writing for activists
>
> Pet loss
>
> Pet supplies

Further reading

Annual events calendar

List of U.S. companies that don't test their
> products on animals

Ingredients that are *always* derived from animals

Ingredients that *may be* derived from animals

(The following list of Web sites is current as of the printing of this book.)

ONLINE RESOURCES

General Web Sites of
U.S. Animal Protection Organizations

All for Animals
www.allforanimals.com

American Humane Association
www.americanhumane.org

American Anti-Vivisection Society
www.aavs.org

Animal Legal Defense Fund
www.aldf.org

Animal Protection Institute
www.api4animals.org

Animal Welfare Institute
www.animalwelfare.com

Association of Veterinarians for Animal Rights
www.avar.org

Doris Day Animal League
www.ddal.org

The Fund for Animals
www.fund.org

The Humane Society of the Untied States
www.hsus.org

In Defense of Animals
www.idausa.org

Last Chance for Animals
www.lcanimal.org

The National Anti-Vivisection Society
www.navs.org

New England Anti-Vivisection Society
www.neavs.org

Physicians Committee for Responsible Medicine
www.pcrm.org

People for the Ethical Treatment of Animals
www.peta-online.org

National and Worldwide Directories

Animal Concerns
www.animalconcerns.org

Hugs for Homeless Animals
www.h4ha.org

Petsville
www.petsville.com

World Animal Net
www.worldanimal.net

Lost and Found Pets

Lost and Found
www.lostandfound.com

Pet Club of America
www.petclub.org

Pet Finder
www.petfinder.org

Sherlock Bones
www.sherlockbones.com

Letter Writing for Activists
Doris Day Animal League
www.ddal.org/leghomepage.html

Pet Loss
Association for Pet Loss and Bereavement
www.aplb.org

Pet Supplies
Petopia
www.petopia.com

PETsMART
www.petsmart.com

FURTHER READING

Newspapers/Magazines

Animal People, a newspaper for people who care about animals. Published ten times annually. PO Box 960, Clinton, WA 98236-0960, (360) 579-2505, www.animalpeoplenews.org.

The Animals' Agenda, a bi-monthly magazine featuring investigations, analysis, commentary, grass roots reports, unsung heroes, book reviews, and more. 1301 S. Baylis St., Suite 325, Baltimore, MD 21224, www.animalsagenda.org.

Animal Fair, a lifestyle magazine for animal lovers, Animal Fair Media, Inc., 545 Eighth Ave., 6th Floor, New York, NY 10018, www.animalfair.com.

The Bark, a cultural/arts magazine exploring the unique bond between humans and dogs, published quarterly. 2810 Eighth St., Berkeley, CA 94710, www.thebark.com.

Books
Co-Existing With Wildlife

Living With Wildlife: How to Enjoy, Cope With, and Protect North America's Wild Creatures Around Your Home and Theirs by Diana Landau.

Wild Neighbors: The Humane Approach to Living With Wildlife by John Hadidian, Guy R. Hodge, and John W. Grandy (editors).

Pet Theft

The Animal Dealer: Evidence of Abuse of Animals in the Commercial Trade 1952-1997, Available from the Animal Welfare Institute. PO Box 3650, Washington, DC 20007, www.awionline.org.

Stolen for Profit by Judith Reitman.

Vegetarianism & Veganism

Diet for a New America: How Your Food Choices Affect Your Health, Happiness and the Future of Life on Earth by John Robbins.

Foods For Life by Neal Barnard, M.D.

Vegan: The New Ethics of Eating by Erik Marcus.

Animals in Laboratories

42 Ways to Help Animals in Laboratories, published by The Humane Society of the United States. Send $4.50 to: Animal Research Issues, The Humane Society of the United States, 2100 L St., NW, Washington, DC 20037.

Animal Testing and Consumer Products by Heidi J. Welsh, published by Investor Responsibility Research Center, www.irrc.org.

Animal Experimentation, a Harvest of Shame by Moneim A. Fadali, M.D. Hidden Springs Press. P.O. Box 29613, Los Angeles, CA 90029.

Expressions 4, a special publication of the National Anti-Vivisection Society (NAVS). Order through NAVS at www.navs.org or (800) 888-6287.

From Guinea Pig to Computer Mouse: Alternative Methods for a Humane Education by Ursula Zinko.

Uplifting and Inspiring Books About Animals

Angel Animals, Exploring Our Spiritual Connection with Animals by Allen and Linda Anderson (A Plume Book).

Conversations with Animals by Lydia Hiby with Bonnie S. Weintraub.

Chicken Soup for the Cat and Dog Lover's Soul, co-authored by Jack Canfield, Mark Victor Hansen, Marty Becker, D.V.M., and Carol Kline.

Chicken Soup for the Pet Lover's Soul, co-authored by Jack Canfield, Mark Victor Hansen, Marty Becker, D.V.M., and Carol Kline.

Out of Harm's Way: The Extraordinary True Story of One Woman's Lifelong Devotion to Animal Rescue by Terri Crisp.

Short Tails and Treats from Three Dog Bakery by Dan Dye and Mark Beckloff.

Factory Farming

Dead Meat by Sue Coe, 1996. Available from Farm Sanctuary, www.factoryfarming.com.

Prisoned Chickens, Poisoned Eggs: An Inside Look at the Modern Poultry Industry by Karen Davis. Available from United Poultry Concerns, PO Box 150, Machipongo, VA 23405, (757) 678-7875, www.upc-online.org.

Slaughterhouse by Gail A. Eisnitz. Available from the Humane Farming Association, PO Box 3577, San Rafael, CA 94912, (415) 771-CALF, www.hfa.org.

Dissection

Dissection: Lessons in Cruelty, People for the Ethical Treatment of Animals Fact Sheet. Order through PETA at www.peta-online.org.

Vivisection and Dissection in the Classroom: A Guide to Conscientious Objection by Gary L. Francione and Anna E. Charlton, 1992.

Animal Adoption and Animal Shelters

Are You the Pet for Me? Choosing the Right Pet for Your Family by Mary Jane Checchi.

Lost and Found: Dogs, Cats, and Everyday Heroes at a Country Animal Shelter by Elizabeth Hess.

Pet Loss

Three Cats, Two Dogs: One Journey Through Multiple Pet Loss by David Congalton.

General Animal Welfare and Animal Rights Books

Animal Liberation: A New Ethics for Our Treatment of Animals by Peter Singer.

Animal Rights, A Handbook for Young Adults by Daniel Cohen.

Animal Rights: A Beginner's Guide (2nd Edition) by Amy Blount Achor.

Disposable Animals by Craig Brestrup.

Ethics Into Action: Henry Spira and the Animal Rights Movement by Peter Singer.

Kids Can Save the Animals!: 101 Easy Things To Do by Ingrid Newkirk.

Save the Animals!: 101 Easy Things You Can Do by Ingrid Newkirk.

The Way of Compassion: Survival Strategies for a World in Crisis edited by Martin Rowe.

You Can Save the Animals: 251 Simple Ways to Stop Thoughtless Cruelty by Ingrid Newkirk.

ANNUAL EVENTS CALENDAR

January
All for Animals founded, January 1, 1997.
National Bird Day, January 5.
Albert Schweitzer born, January 14, 1875.

February
Prevent a Litter (P.A.L.) Month, month-long event.
National Wild Bird Feeding Month, month-long event.
General Motors ends animal crash tests, February, 1993.
Ground Hog Day, February 2.
National Pet Theft Awareness Day, February 14 (also Valentine's Day).
Spay Day USA, last Tuesday in February.

March
Cambridge, Massachusetts is the first U.S. city to ban the LD50 and Draize Tests, March 1991.
Great American Meatout Day, March 20 (first day of Spring).
The Ark Trust Genesis Awards, fourth Saturday in March.

April
Prevention of Animal Cruelty Month, month-long event.
Mary Kay Cosmetics announces a permanent ban on animal testing, 1999. (A moratorium went into effect in 1989.)

Colgate-Palmolive announces a moratorium on animal testing, April 1999.

World Week for Animals in Laboratories, last week in April.

National Dolphin Day, remembrance of all sea creatures, April 14.

John Muir (environmentalist) born, April 1838.

Earth Day, on or about April 22.

May

Humane Sunday, first Sunday in May.

National May Day for Mutts, first Sunday in May.

Be Kind to Animals Week, second week in May.

National Keep Your Cat Indoors Day, second Saturday in May.

North Shore Animal League Adopt-a-thon, first week in May.

National Veal Ban Action Day, second Sunday in May (also Mother's Day).

National Dog Bite Prevention Week, third week in May.

National Animal Disaster Preparedness Day, third Saturday in May.

Marine Mammal Freedom Weekend, last weekend in May.

June

Adopt a Shelter Cat Month, month-long event.

Animal Rights Awareness Week, third week in June.

Avon is the first major U.S. company to stop animal testing, June 2, 1989.

Procter and Gamble announces an end to animal testing for its current beauty, fabric, and home care products, but not for new product formulas or food items, June 1999.

Pet Appreciation Week, first week in June.

National Take Your Dog to Work Day, last Friday in June.

July

Federal funding canceled for baboon head injury experiments at the University of Pennsylvania, July 18, 1995.

"Wheel of Fortune" bans fur prizes, July 13, 1990.

August
Animal Welfare Act enacted, August 24, 1966.
Henry Bergh, ASPCA founder born, August 29, 1813.
National Homeless Animals' Day, third Saturday in August.

September
National Dog Week, second week in September.
National Farm Animal Awareness Week, third week in
 September.
Silver Spring (Maryland) monkeys rescued from Institute for
 Behavioral Research, September 11, 1981.
National Pet Memorial Day, second Sunday in September.

October
Vegetarian Awareness Month, month-long event.
Cut Out Dissection Month, month-long event.
Adopt a Shelter Dog Month, month-long event.
World Vegetarian Day, October 1.
Mohandas Gandhi's birthday, October 2.
World Farm Animals Day, October 2.
Feast of St. Francis of Assisi, patron saint of animals, October 4.
World Animals Day, October 4.
Endangered Species Act enacted, October 15, 1966.
National Wildlife Ecology Day, last Saturday in October.
Marine Mammal Protection Act enacted, October 21, 1972.
Dolphin Protection Consumer Information Act (created
 "Dolphin Safe Tuna" labeling, October 27, 1990).

November
Adopt a Turkey Project, month-long event.
National Animal Shelter Appreciation Week, first week in
 November.
Benetton Clothing Co. stops animal tests, November 17, 1988.
Fur Free Friday, Friday following Thanksgiving Day.

December

Horse Protection Act enacted, December 9, 1970.

Free Roaming Wild Horse and Burro Protection Act enacted, December 19, 1971.

List of U.S. Companies That Don't Test Their Products on Animals

The following companies manufacture products that are not tested on animals. Those marked with a dot (•) meet the Corporate Standard of Compassion for Animals as discussed in chapter 2. Those marked with an asterisk (*) manufacture strictly vegan products—made without animal ingredients, such as milk and egg byproducts, slaughterhouse byproducts, sheep lanolin, honey, or beeswax.

This list of cruelty-free companies is current as of the printing of this book. For a more current listing, visit the All for Animals Web site at www.allforanimals.com/cruelfree1.htm or order a cruelty-free shopping guide by sending $1.00 (to cover postage) to:

All for Animals
1324 State Street, #J109
Santa Barbara, CA 93101

*ABBA Products, Inc.
ABEnterprises
Abercrombie & Fitch (The Limited)
Abkit, Inc. (CamoCare)
*Abra Therapeutics
*Advanage Wonder Cleaner
*Ahimsa Natural Care
•Alba Botanica
Alexandra Avery Purely Natural
Alexandra de Markoff (Parlux Fragrances)
•*Allens Naturally
Almay (Revlon)
Aloegen Natural Cosmetics (Levlad)
Aloette Cosmetics
Aloe Up

Aloe Vera of America
Alvin Last
*Amazon Premium Products
•*American Formulating & Manufacturing
American International
American Safety Razor (Personna, Flicker, Bump Fighter)
*America's Finest Products Corp.
Amitée Cosmetics
Amoresse Labs
Amway
Ancient Formulas
Andrea International Industries (Clear Perfection)
The Apothecary Shoppe

Aramis (Estée Lauder)
Arbonne International
Ardell International
Arizona Natural Resources
Aromaland
Aroma Vera
*Astonish Industries
*Atmosa Brand Aromatherapy
 Products
Aubrey Organics
Aunt Bee's Skin Care
*Aura Cacia
•*Auromère Ayurvedic Imports
The Australasian College of
 Herbal Studies
•Autumn-Harp
•Avalon Natural Products
Aveda
*Avigal Henna
Avon
*Ayurherbal Corp.
*Ayurveda Holistic Center
Bare Escentuals
*Basically Natural
*Basic Elements Hair Care
 System
Basis (Beiersdorf)
Bath & Body Works
Bath Island
•Baudelaire
BeautiControl Cosmetics
Beauty Naturally
•*Beauty Without Cruelty
Beehive Botanicals
Beiersdorf (Nivea, Eucerin, La
 Prairie)

Bella's Secret Garden
Belle Star
Berol (Sanford)
•Better Botanicals
Beverly Hills Cold Wax
*BioFilm
*Biogime International
Biokosma (Caswell-Massey)
•*Bio Pac
Bio-Tec Cosmetics
Biotone
Bobbi Brown (Estée Lauder)
Bo-Chem Co.
Body Encounters
Bodyograph
•The Body Shop
Body Time
Bon Ami/Faultless Starch
Bonne Bell
•Börlind of Germany
*Botan Corporation
*Botanics Skin Care
*Brocato International
•*Bronzo Sensualé
*Brookside Soap Company
*Bug Off
Caeran
California Styles
California SunCare
CamoCare Camomile Skin
 Care Products (Abkit)
•*Candy Kisses Natural Lip
 Balm
Carina Supply
Carlson Laboratories
Carma Laboratories

Caswell-Massey
•CBI
Celestial Body
Chanel
Chatoyant Pearl Cosmetics
Christian Dior
Christine Valmy
Chuckles (Farmavita USA)
CiCi Cosmetics
*Cinema Secrets
*Citius USA
Citré Shine
Clarins of Paris
•*Clear Conscience
•*Clearly Natural Products
*Clear Vue Products
Clientele
Clinique Laboratories
*Colorations
Color Me Beautiful
•Color My Image
Columbia Cosmetics Mfg.
Common Scents
The Compassionate Consumer
Compassionate Cosmetics
Compassion Matters
Conair (Jheri Redding)
Concept Now Cosmetics
 (CNC)
Cosmair (L'Oréal, Lancôme,
 Maybelline)
Cosmyl
*Cot 'N Wash
Country Comfort
*Country Save Corp.
*Countryside Fragrances

Crabtree & Evelyn
Crème de la Terre
*Crown Royale, Ltd.
*CYA Products
Dallas Manufacturing Co.
DampRid, Inc.
Decleor USA
•Dena Corporation
*Deodorant Stones of America
Derma-E
Dermalogica
Dermatologic Cosmetic Labs
Desert Essence
DeSoto (Keystone
 Consolidated Industries)
Diamond Brands
•Dickinson Brands, Inc.
Donna Karan Beauty
 Company (Estée Lauder)
Dr. A.C. Daniels
•*Dr. Bronner's Magic Soaps
•Dr. Goodpet
Dr. Hauschka Skin Care
*Dr. Singha's Natural
 Therapeutics
•Earth Friendly Products
*Earthly Matters
•Earth Science
*Earth Solutions
Eberhard Faber (Sanford)
E. Burnham Cosmetics
Ecco Bella Botanicals
•Eco-DenT
Eco Design Company
Ecover
Edward & Sons Trading Co.

Elizabeth Grady Face First
•*Elizabeth Van Buren
 Aromatherapy
•English Ideas
•*Espial International
*Essential Aromatics
Essential Oil Company
•*Essential Products of
 America
Estée Lauder (Clinique,
 Origins)
Eucerin (Beiersdorf)
European Gold
*EuroZen
Eva Jon Cosmetics
Evans International
Every Body, Ltd. (Mountain
 Ocean)
Face Food Shoppe
Faces by Gustavo
Facets/Crystalline Cosmetics
Faith Products, Ltd.
Farmavita USA (Chuckles)
Faultless Starch (Bon Ami)
Fernand Aubry
•Fleabusters/Rx for Fleas
*Flower Essences of Fox
 Mountain
Focus 21 International
Food Lion (house-brand
 products only)
Forest Essentials
Forever Living Products
•*Forever New International
Fragrance Impressions, Ltd.
Framesi, USA

*Frank T. Ross (Nature Clean)
Freeda Vitamins
*Free Spirit Enterprises
•*French Transit
*Frontier Natural Products
 Co-op
Fruit of the Earth
•Gabriel Cosmetics
Garden Botanika
Garmon Corp.
Garnier (L'Oréal)
Georgette Klinger
Gigi Laboratories
*Giovanni Cosmetics
Golden Pride/Rawleigh
Goldwell Cosmetics (USA)
*Green Ban
Gryphon Development (The
 Limited)
•Halo Purely for Pets
Hard Candy
•*Hawaiian Resources
The Health Catalog
•HealthRite/Montana
 Naturals
•Healthy Solutions
*Healthy Times
Helen Lee Skin Care &
 Cosmetics
*Hemp Erotica
Henri Bendel (The Limited)
•Herbal Products &
 Development
•*The Herb Garden
*h.e.r.c. Consumer Products
Hewitt Soap Company

Hobé Laboratories
Homebody (Perfumoils)
Home Health Products
•*Home Service Products
House of Cheriss
H2O Plus
Huish Detergents
Ida Grae (Nature's Colors
 Cosmetics)
Il-Makiage
ILONA
i Natural Cosmetics (Cosmetic
 Source)
*Innovative Formulations
*International Rotex
International Vitamin Corp.
InterNatural
IQ Products Company
•Island Dog Cosmetics
*IV Trail Products
•Jacki's Magic Lotion
James Austin Company
Jane (Estée Lauder)
•Jason Natural Cosmetics
J.C. Garet
Jeanne Rose Aromatherapy
•Jennifer Tara Cosmetics
Jessica McClintock
Jheri Redding (Conair)
Joe Blasco Cosmetics
John Amico Expressive Hair
 Care
•*John Paul Mitchell Systems
*JOICO Laboratories
Jolen Creme Bleach
•*J.R. Liggett, Ltd.

Jurlique Cosmetics
Katonah Scentral
K.B. Products
Kenic Pet Products
*Ken Lange No-Thio
 Permanent Waves
Kenra Laboratories
Kiehl's
•Kiss My Face
Kleen Brite Laboratories
•KMS Research
•*KSA Jojoba
*LaCrista
•*Lady of the Lake
•Lakon Herbals
*LaNatura
Lancôme (Cosmair)
Lander Co.
*L'anza Research International
La Prairie (Beiersdorf)
Lee Pharmaceuticals
•Levlad/Nature's Gate
*Liberty Natural Products
Life Dynamic
*Life Tree Products (Sierra
 Dawn)
Lightning Products
Lily of Colorado
•Lime-O-Sol Company
•*Little Forest Natural Baby
 Products
Liz Claiborne Cosmetics
•*Lobob Laboratories
Logona USA
L'Oréal (Cosmair, Maybelline,
 Lancôme)

Lotus Light
•Louise Bianco Skin Care
M.A.C. Cosmetics
Magick Botanicals
The Magic of Aloe
Mallory Pet Supplies
Manic Panic (Tish & Snooky's)
*Marcal Paper Mills
Marché Image Corp.
Marilyn Miglin Institute
•Mary Kay Cosmetics
*Masada
Mastey de Paris
Maybelline (L'Oréal)
*Meadow View Garden
Mehron
•Mère Cie
Merle Norman
•*Mia Rose Products
•Michael's Naturopathic Programs
Michelle Lazar Cosmetics, Inc.
*Micro Balanced Products
Mill Creek
Mira Linder Spa in the City
•Montagne Jeunesse
•Montana Naturals/Health Rite
*Mother's Little Miracle
Mountain Ocean (Every Body Ltd.)
Mr. Christal's
*Murad
•Muse, Body Mind Spirit

•Nadina's Cremes
*Nala Barry Labs
Narwhale of High Tor, Ltd.
•*Natracare
•Naturade Cosmetics
Natura Essentials
Natural (Surrey)
Natural Animal Health Products
*Natural Bodycare
Natural Chemistry
*Naturally Yours, Alex
*Natural Products Co.
*Natural Research People
•*Natural Science
Natural World
*Nature Clean (Frank T. Ross)
*Nature de France
Nature's Acres
*Nature's Best (Natural Research People)
*Nature's Country Pet
•Nature's Gate/Levlad
Nature's Plus
Nectarine
*Neocare Labs
*Neo Soma
Neutrogena
*New Age Products
*Neway
•Neways
*New Chapter Extracts
•New Vision
Nexxus
Nikken
•*Nirvana

Nivea (Beiersdorf)
No Common Scents
Nordstrom Cosmetics
*Norelco
North Country Glycerine
 Soap
N/R Laboratories
NuSkin Personal Care
NutriBiotic
*Nutri-Cell
Nutri-Metics International
The Ohio Hempery
*Oliva
OPI Products
*Orange-Mate
Oriflame USA
Origins Natural Resources
 (Estée Lauder)
Orjene Natural Cosmetics
Orlane
Orly International
Otto Basics–Beauty 2 Go!
Oxyfresh Worldwide
*Pacific Scents
*Parlux Fragrances (Perry Ellis,
 Todd Oldham)
*Pashtanch
Pathmark Stores
Patricia Allison Natural
 Beauty
*Paul Mazzotta
Perfect Balance Cosmetics
PetGuard
*Pets 'N People
*Pharmagel International

Pierre Fabre (Physicians
 Formula)
*Pilot Corporation of America
*Planet
PlantEssence
Prescription Plus
Prescriptives
Prestige Cosmetics
Prestige Fragrances
The Principal Secret
Professional Pet Products
•Pro-Tec Pet Health
•Protocol Cosmetics
Puig USA
*Pulse Products
*Pure & Basic Products
*Pure Touch Therapeutic Body
 Care
•Queen Helene
•Rachel Perry
Rainbow Research
 Corporation
The Rainforest Company
Ralph Lauren Fragrances
 (Cosmair)
*Real Animal Friends
Recycline
Redken Laboratories
 (Cosmair)
•Rejuvi Skin Care
Reviva Labs
Revlon (Almay, Jean Naté)
*Rivers Run
Royal Herbal
*Royal Labs Natural
 Cosmetics

Rusk
•Sacred Blends
Safeway (house-brand
 products only)
*Sagami
Sanford (Berol, Eberhard
 Faber)
*Santa Fe Botanical Fragrances
*Santa Fe Soap Company
*Sappo Hill Soap Works
Sassaby (Jane, Estée Lauder)
Schiff Products
Scruples
•Sea Minerals
Sea-renity
Sebastian International
 (Wella)
Secret Gardens
•Senator USA
*SerVaas Laboratories
•*Seventh Generation
•*Shadow Lake
*The Shahin Soap Co.
Shaklee Corporation
Shikai (Trans-India Products)
•Shirley Price Aromatherapy
Shivani Ayurvedic Cosmetics
•*Simplers Botanical Co.
Simple Wisdom
Sinclair & Valentine
*Sirena (Tropical Soap Co.)
Skin Essentials
Smith & Vandiver
•The Soap Opera
•Soapworks

Sojourner Farms Natural Pet
 Products
Solgar Vitamin Co.
Sombra Cosmetics
•Sonoma Soap Company
SoRik International
Soya System
Spa Natural Beauty
Staedtler, Ltd.
Stanley Home Products
Steps in Health
*Stevens Research Salon
 Products
•St. John's Herb Garden
Studio Magic
Sukesha (Chuckles)
*Sumeru
•*SunFeather Natural Soap
 Co.
Sunrider International
Sunrise Lane Products
*Sunshine Natural Products
*Sunshine Products Group
Supreme Beauty Products Co.
Surrey
Tammy Taylor Nails
TaUT by Leonard Engelman
Ted Stone Enterprises
TerraNova
*Terressentials
Thursday Plantation
Tish & Snooky's (Manic
 Panic)
•*Tisserand Aromatherapy
•Tom's of Maine
Tova Corporation

Trader Joe's Company
Travel Mates America
Tressa
TRI Hair Care Products
Trophy Animal Health Care
*Tropix Suncare Products
Truly Moist (Desert Naturels)
Tyra Skin Care
*The Ultimate Life
Ultima II (Revlon)
*Ultra Glow Cosmetics
•Unicure, Inc.
•Un-Petroleum Lip Care
Upper Canada Soap & Candle Makers
•Urban Decay
*USA King's Crossing (Total Shaving Solution)
*U.S. Sales Service (Crystal Orchid)

•Vermont Soapworks
*Veterinarian's Best
Victoria's Secret
Virginia Soap, Ltd.
*Von Myering by Krystina
•V'tae Parfum & Body Care
Wachters' Organic Sea Products
•Warm Earth Cosmetics
•Weleda
The Wella Corporation (Sebastian)
Wellington Laboratories
*Whip-It Products
Wind River Herbs
WiseWays Herbals
Womankind
Wysong
Zia Natural Skincare

Ingredients That Are
Always Derived from Animals

If you love animals, chances are that you would like to avoid using products which contain animal-derived ingredients. However, determining whether an ingredient comes from a plant, animal, or synthetic process can be tricky. The following list of animal-derived ingredients was originally compiled by the American Vegan Society and reprinted in the National Anti-Vivisection Society's book *Personal Care for People Who Care*, currently in its 10th edition.

Albumin
Ambergris
Amniotic fluid
Amylase
Anchovy
Angora
Animal oils and fats
Arachidonic acid
Aspic
Astrakhan
Bee products
Bee pollen
Beeswax
Bone ash
Bone meal
Brawn
Carmine/carminic acid
Casein
Cashmere
Castoreum (castor)*
Catgut
Caviar

Chamois
Chitin
Cholesterin, cholesterol
Cochineal
Cod liver oil
Coral
Down
Duodenum substances
Egg albumin
Egg protein
Egg white
Eider down
Elastin
Enzymes
Feathers
Felt
Fish liver oil
Fish scales
Fur
Gelatin
Glycerides
Guanine

*Not to be confused with Castor Oil, which is not animal-derived.

Hide
Hide glue
Honey
Horsehair
Isinglass
Lactose
Lanolin (also, lanol or lanate
 derivatives)
Lard
Leather
Lipase
Luna sponge
Milk protein
Mink oil
Mohair
Musk
Oleic oil
Oleostearin
Parchment
Pearl
Pearl, cultured
Pepsin
Placenta

Polypeptides
Progesterone
Propolis
Quatemium 27
Rennet
RNA/DNA
Roe
Royal jelly
Sable
Shellac
Silk
Sodium 5'-inosinate
Sperm oil
Spermaceti wax
Squalene/squalane
Suede
Suet
Tallow
Testosterone
Vellum
Vitamin D3
Whey
Wool

Ingredients That
May Be **Derived from Animals**

This list of ingredients was also compiled by the American Vegan Society:

Adrenaline
Allantoin
Amino acids
Anticaking agent
Aspartic acid
Bristle
Calcium stearate
Caprylic acid
Carmel
Cetyl alcohol
Charcoal
Clarifying agent
Collagen
Coloring
Cortisone
Cysteine L-form, cystine
Emulsifiers
Estrogen
Fatty acids
Flavorings
Gelling agent
Glazing agent
Glutamic acid
Glycerin
Humectants
Hydrolized proteins
Insulin

Keratin
L'cysteine hydrochloride
Lactic acid
Lecithin
Linoleic acid
Lipoids/lipids
Lutein
Magnesium stearate
Maple sugar
Natural source
Nucleic acid
Nutrients
Oleic acid
Panthenol
Proteases
Releasing agents
Solvent
Sponge
Stabilizers
Stearates/stearic acid
Steroid
Sugar
Urea
Velvet
Vitamin A
Vitamin B12

For more information on animal ingredients, contact:
 American Vegan Society
 56 Dinshah Dr.
 P.O. Box 369
 Malaga, NJ 08328
 (856) 694-2887

To order a copy of the book *Personal Care for People Who Care* (current price: $9.50), contact:
 The National Anti-Vivisection Society
 53 W. Jackson Blvd., Suite 1552
 Chicago, IL 60604
 (800) 888-NAVS
 www.navs.org

In Conclusion

Thank you for taking the time to read this book. I hope you have learned some easy, valuable tips on your journey toward a more cruelty-free lifestyle. I suggest you start slowly and try doing one or two of the suggestions in the book each month. You'll be pleasantly surprised at the wonderful way you'll feel about yourself, and the gratitude animals will express to you for your kindness.

I ask that you do one additional thing to help animals: *spread the word*. After you have finished reading this book, give it to a friend or donate it to your local library, so even more people may learn about the many benefits of living life in a more humane, compassionate way.